DRAWING REALISTIC
Textures IN *Pencil*

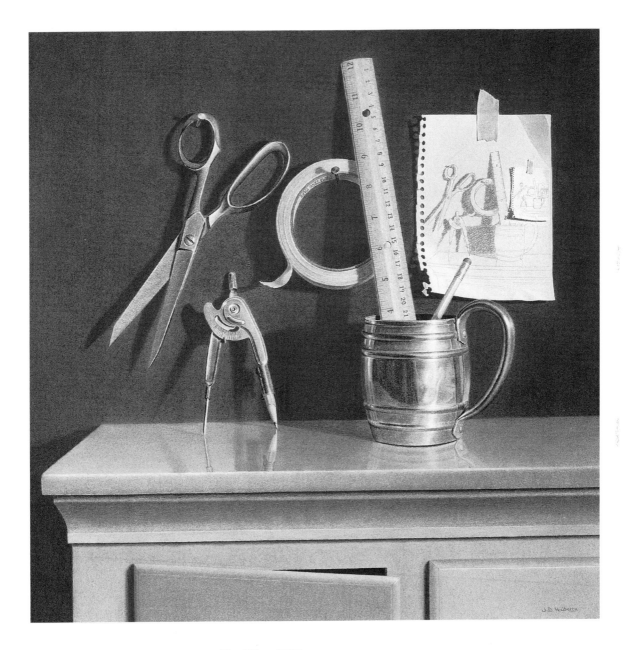

J. D. HILLBERRY

NORTH LIGHT BOOKS
CINCINNATI, OHIO

About the Author

A natural ability and strong desire to draw surfaced early in J.D. Hillberry's life. As a boy, he began developing his own techniques of blending charcoal and graphite to achieve a realistic look in his drawings. Throughout his career, he has tried to push the limits of realistic expression with these mediums.

J.D. has shown his work in some of the most prestigious invitational shows in the country, including the Artists of America show in Denver, Colorado, and the Great American Artists exhibition at the Cincinnati Museum Center in Cincinnati, Ohio. He has taught a number of workshops and has conducted demonstrations at many outdoor art fairs, including the nationally acclaimed Cherry Creek Arts Festival. Some of Hillberry's drawings have been reproduced as limited edition prints that are sold in galleries and frame shops across the country. His work has been featured in national publications such as *The Artist's Magazine*, *Revue* and *Western Horseman Magazine*. J.D. is also featured in a book about illusion in art that is published and distributed in Europe.

Drawing Realistic Textures in Pencil. Copyright © 1999 by J.D. Hillberry. Manufactured in China. All rights reserved. No part of this book may be reproduced in any form or by any electronic or mechanical means including information storage and retrieval systems without permission in writing from the publisher, except by a reviewer, who may quote brief passages in a review. Published by North Light Books, an imprint of F&W Publications, Inc., 4700 East Galbraith Road, Cincinnati, Ohio 45236. (800) 289-0963. First edition.

Other fine North Light Books are available from your local bookstore or art supply store, or direct from the publisher.

06 05 04 8 7

Library of Congress Cataloging-in-Publication Data

Hillberry, J.D.
 Drawing realistic textures in pencil / by J.D. Hillberry.—1st ed.
 p. cm.
 Includes index.
 ISBN 0-89134-868-9 (pbk.)
 1. Texture (Art) 2. Pencil drawing—Technique. I. Title.
NC890.H55 1999
741.2′4—dc21 98-29965
 CIP

Edited by Joyce Dolan
Production edited by Michelle Howry
Designed by Angela Lennert Wilcox

To my wife, Vicki, and my children, Taylor and Logan,
for tolerating my absence during the writing of this book.

Acknowledgments

Everyone who has spent enough time drawing, painting or sculpting has experienced that slightly *altered state of consciousness* that comes when you really get involved with what you're doing. You are not aware of the passage of time, and conscious thought disappears. This meditative state is the right side of the brain at work. To explain art techniques, the left side of the brain must continually interrupt the right side, figure out what it is doing and transform it into words. This constant shifting of mental states is like going from a hot tub to a cold shower and back again. I would like to express my gratitude to my editor, Joyce Dolan, for keeping me in the cold shower long enough to explain my methods. I would also like to thank Rachel Wolf, for recommending me to North Light Books.

A special thanks to my parents, Darwin and Ruth Hillberry, for encouraging me to always pursue my interests. I would also like to acknowledge my brother, Tony, for being my best friend, spiritual advisor and occasional model.

Thanking my wife is something I don't do often enough. My daughter was six weeks old when I told my wife I wanted to try to make a living as a full-time artist. I owe a great deal to her for believing in me. In the beginning, neither of us realized how much I would need her to make it work. Without her help in running the business, I would be forced to get a "real job."

Finally, I would like to thank the collectors of my work for their support through the years and my students for their interest in my techniques.

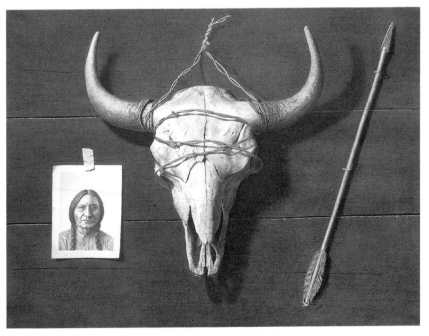

CULTURAL CAPTIVITY
Charcoal, graphite and carbon pencils on Crescent
watercolor board, 29″×39″ (72.5cm×97.5cm)
Collection of J.L. and Suzy Witzler

Table of Contents

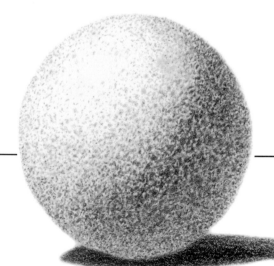

Introduction

The key to rendering the look of any texture begins with your eyes. Before you can simulate surface textures you must learn to recognize them. Look up from this book and glance around. There are as many types of textures as there are colors. Feel the slick paper of this page you are reading. Now touch a piece of your clothing. You can feel a textural difference.

If you wanted to include this page and the fabric of your clothes in a realistic drawing, you would need to render the essential qualities that make paper look like paper and fabric look like fabric. Exaggerating the texture of your clothing enhances the look of the smoothness of the paper. I use this theory of opposites to heighten the realism in my work.

To make a texture look smoother, place it next to a rougher one; to make white look whiter, place it

next to a dark value. No matter what your subject, adding texture and contrast also adds depth and realism to your drawings.

In my view, drawings fall into two categories: contour line drawings and tonal drawings. A line drawing delineates the edges of a form. It is void of the shading that produces a three-dimensional look. Many line drawings are sensitive, finished pieces of art, but I prefer to add light, shadow and texture in my work. I begin with a line drawing, but only as the *skeleton* that holds the values and textures. It is an important part of drawing realistically, however.

To get the most out of this book, you should have some knowledge of how to draw the contours of the shapes you see. If the proportions and perspective are incorrect, adding texture and shading will not make it look real. The most common problem when attempting realism is letting the skeleton show through in the finished piece. The real world does not have lines encircling the outer edges of objects, so avoid hard outlines in your drawings.

BIG LEAGUE DREAMS
Charcoal and graphite on Arches 140-lb. (300gsm) watercolor paper
10″ × 22″ (25cm × 55cm)
Photo by Richard Stum

"LUCKY DRAW #2"
Original Drawing
By
JD Hillberry
Price: N. F. S.

Materials

All it takes to draw is a pencil and a piece of paper. This thought amazes me when I look around at all the materials I have accumulated while exploring numerous drawing techniques. I've discovered that by using a variety of pencils, blenders and erasers you can increase the realism in your drawings. The good news is that all of the items I routinely use are inexpensive compared to the price of working with other media, and many traditional art stores let you experiment with pencils and paper before you buy them.

LUCKY DRAW # 2
Charcoal, graphite and carbon on Crescent watercolor board
21″ × 17½″ (52.5cm × 17.5cm)
Photo by Richard Stum

Pencils

By taking advantage of the inherent qualities found in three basic types of pencils, you will automatically increase the range of values that are possible and add more texture to your drawings.

Graphite Pencils

Artist-grade graphite pencils are more refined than your old no. 2, allowing for smoother lines on the paper. These pencils come in a wide range of hardness and softness and are labeled with letters and numbers. Pencils with the letter B are the softest. The higher the number in front of the B, the softer the pencil. The softest graphite pencil available is 9B, which produces the darkest line. Harder pencils make lighter marks and are noted with the letter H, with 9H being the hardest. Hard pencils are best for fine detailed work because they hold a sharp point better. A pencil with the letter F has a degree of hardness halfway between the H and B. There are many brands of graphite pencils. A 2B pencil of one brand may be vastly different than the 2B of another brand. I use Berol Turquoise drawing pencils.

Charcoal Pencils

Many people who are used to the feel of graphite effortlessly gliding across their paper find charcoal too abrasive. Several years ago, I came across Ritmo charcoal pencils. They combine the blackness of charcoal with the smoothness of graphite. They are available in degrees of hardness ranging from HB to 3B. Other brands of charcoal pencils work just as well, although they create a slightly different texture. All charcoal pencils smudge easily, so if you're not familiar with this medium read the section *Keep Your Drawing Clean* on page 18.

Carbon Pencils

I use two different types of carbon pencils: Wolff's and Conté carbon. They both come in several degrees of hardness and, like other pencils, are labeled with the letters H and B. The Wolff's carbon pencil has recently been reformulated to give a smoother feel and richer blacks than the old version. It reflects light differently than charcoal and graphite. Conté carbon is made of graphite and clay. The clay gives it a warmer tone than either charcoal, graphite or Wolff's carbon. When either of these carbon pencils are used in combination with the other media, their inherent characteristics make them ideal for separating subjects containing similar values.

Graphite Sticks

Graphite sticks simply contain the graphite in a block shape. This allows you to use the broad edge to lay in large areas of tone. They are usually available only in the softer B range of graphite.

Charcoal Sticks

There are two types of charcoal sticks. *Vine charcoal* is made from burnt willow branches. It comes in a variety of sizes with densities of hard, medium and soft. Vine charcoal is easy to blend into a rich velvety tone. *Compressed charcoal* is re-formed with carbon or clay added. It's available in medium to very soft grades and is capable of producing rich black tones. It's more difficult to erase and blend than vine charcoal.

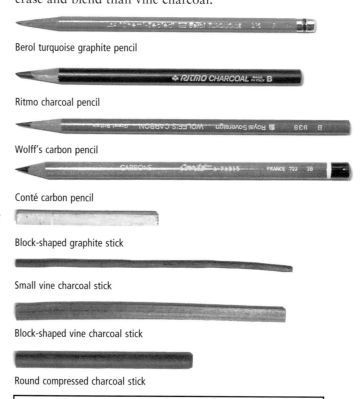

Berol turquoise graphite pencil

Ritmo charcoal pencil

Wolff's carbon pencil

Conté carbon pencil

Block-shaped graphite stick

Small vine charcoal stick

Block-shaped vine charcoal stick

Round compressed charcoal stick

Get the Lead Out of Graphite Pencils

The trusty no. 2 pencils you used in school didn't contain lead. Lead is a metallic element that is not related in any way to the material found in a pencil—graphite.

Graphite was not fully understood until the eighteenth century. It is actually a form of carbon—a non-metallic element. Graphite was previously called *plumbago* or *black lead*. This name persisted, and today graphite pencils are frequently called lead pencils.

Erasers

Erasing is not only used for getting rid of unwanted marks on your paper. It is also a valuable tool for creating textural effects. I use three different types of erasers.

Eraser Pen

This is a hollow plastic holder roughly the size of an ink pen. Round, vinyl eraser refills fit inside the holder, which can be *clicked* to lengthen the eraser. The eraser refills are inexpensive. I use the Pentel Retractable Clic brand eraser pen to make thin, white lines in areas that have already been covered with graphite, charcoal or carbon. It's like drawing with white. Keep a clean, sharp edge on the eraser by trimming off the used portions with a razor blade. This type of vinyl eraser erases more completely than a kneaded eraser and doesn't leave as much eraser residue as a typewriter eraser.

Erasing pen

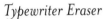

Typing eraser

Typewriter Eraser

This kind of an eraser can be sharpened like a pencil. It is quite abrasive and capable of digging back down to the white of the paper through dark values. This also means it can damage the paper if you aren't careful. It can remove more of the drawing medium than an eraser pen, but it also leaves more residue. If you need a sharp edge, use a razor blade to cut off the end of the eraser.

Kneaded eraser

Kneaded Eraser

This is a soft, pliable eraser that can be molded into any shape you need. I don't even start drawing unless I have one of these nearby. Dabbing with a kneaded eraser leaves no eraser residue. In fact, I use it to pick up the residue left by the typewriter eraser. It doesn't erase as completely as the other two erasers, but it has many other uses. I use a kneaded eraser to:

- Lift charcoal or graphite in shadow areas to indicate reflected light

- Remove smudges in highlights for the final cleanup for a drawing

- Create unique textures by rolling or stroking in blended charcoal

- Clean excess media from the ends the other two erasers.

Blending Tools

Blending Stumps

These are tightly wound paper sticks with points on both ends. They are available in several diameters. Use them to blend larger areas of a medium and also to apply the medium directly for softer effects.

Blending Tortillons

Although these resemble blending stumps, there are significant differences. Tortillons are not wrapped as tightly and are pointed only on one end. They are not as solid as blending stumps. The differences are great enough to cause a dissimilar look to a blended area.

Felt

For much of my blending, I use felt purchased in one-foot (30cm) squares from craft stores. I cut these pieces into 6″ (15cm) squares for easier handling. Use separate pieces of felt for each medium and a clean piece for blending one medium into another. Cut the squares into smaller pieces that you can roll tightly like a tortillon to make a soft blender for small details. Use masking tape to keep the felt rolled.

Paper

Pieces of paper make good blenders. Wrap the paper around one or all of your fingers. The texture of the blending paper effects the outcome. A piece of textured charcoal paper used as a blender produces a different texture than a slick piece of typing paper.

Facial Tissues and Paper Towels

Fold a facial tissue into a small square and use the corner to get into smaller areas. It is very effective for lifting charcoal. Facial tissues will disintegrate quickly, so sometimes paper towels are a better choice for blending larger areas. Make sure you don't use facial tissues that contain lotion or dye that could rub off on your drawing.

Chamois

A clean, dry chamois is great for blending when you want a smooth texture. Stay away from poor quality chamois made for drying your car; this will break apart if rubbed on the paper too vigorously. It's always best to test any new material you plan to use as a blender *before* you use it on your drawing. Rub the chamois on a white piece of paper to see if it leaves any color or residue.

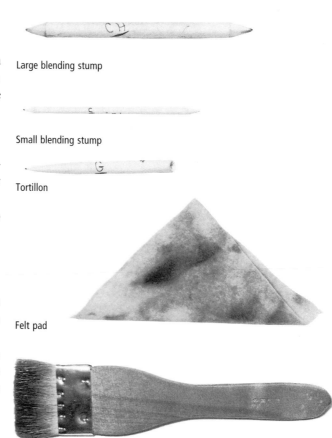

Large blending stump

Small blending stump

Tortillon

Felt pad

Large paintbrush

Small paintbrush

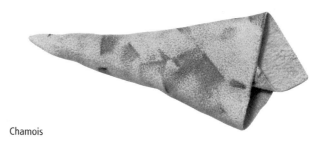

Chamois

Tip
Label your tortillons and stumps with the specific medium you use them on. This keeps you from mixing one medium with another. I use an ink pen to mark *CH* for charcoal, *G* for graphite and *C* for carbon. When you blend one medium with another, it doesn't matter. However, it's best to begin the blending process with a clean blender.

Paper

The type of paper you use affects the appearance of a drawing more than any of the techniques explained in this book. I'll tell you some papers I use and why I like them, but don't let that keep you from experimenting. Every artist has a particular way of applying media to paper. What works for me may not work for you. I have tried the paper recommendations of many pencil artists—whose work I greatly admire—and found some of the surfaces painfully hard to work with.

Choose the Right Paper for the Subject

To produce a variety of realistic looking textures in your drawings, you should find at least two papers that you like to work with. One of the papers should have more *tooth* or texture than the other. If the majority of your drawing contains rough textures, the roughness of the paper can do much of the work for you. Also consider how dark the values need to be in your drawing. Papers with more tooth can create darker values because they hold more of your drawing media. Fine detail work and smooth textures are easier to produce with smoother papers.

Don't Let the Paper Be the Boss

There is nothing worse than fighting with your paper. It's always a losing battle. Some papers are made using a wire mesh that creates a strong directional pattern in the tooth of the paper. The pronounced pattern that emerges when you apply the media to these papers overpowers the textures you are trying to create. If you draw realistic textures, a paper like this would be handy only if your *one and only* subject has a similar texture. When you experiment with papers make sure you try both sides, because the patterned tooth is sometimes only on the front.

My Favorite Papers

Arches 140-lb. (300gsm) hot-press watercolor paper
This paper works well when the majority of the drawing has subjects that contain smooth textures. I use the back of the paper because the front has a patterned tooth. Its smooth surface is excellent for rendering fine details but still holds a moderate amount of media to render some dark values.

Strathmore 400 Series drawing paper This paper has a nice random tooth pattern. It is considered *student grade* since it is not a 100% rag paper. This means it contains some wood pulp that will cause the paper to yellow over time. Don't let this keep you from experimenting with it. For one thing it is cheaper than most of the 100% rag papers.

Watercolor boards and illustration boards These boards also have great drawing surfaces. If you like to work big, you'll have fewer problems with your drawings wrinkling on these thick surfaces. I use Crescent No. 115 hot-press watercolor board for many of my larger drawings that contain rough textures. The surface paper attached to this board is Strathmore 100% rag watercolor paper. Cold-press papers and boards typically have a much rougher texture, but Crescent No. 310 100% rag cold-press illustration board has a remarkably smooth texture and holds a lot of the drawing medium for rendering dark values.

Flattening the Tooth of the Paper

It's always best to let the surface of the paper work for you by using a smooth paper for drawings with smooth subjects and a rougher paper for more textured subjects. For drawings that contain both smooth and rough textures you need to decide which type of paper will suit the overall drawing. If you use a smooth paper, you can create the rough areas by using techniques and media that produce more texture. These include techniques found in chapter two: employing textural strokes like cross-hatching and stippling, using softer pencils, using blenders that create more texture, not blending at all and using the indenting technique to produce more surface texture. If you choose a paper with more texture, you can flatten the tooth of the paper in areas where the smoother texture is needed. This technique works best for smooth reflective surfaces like glass or metal.

Flattening the Tooth of the Paper
Use the rounded metal end of a Berel Turquiose pencil to smash down the tooth of the paper. Small, overlapping, circular strokes work best to flatten the tooth evenly.

Tooth of the paper flattened

Tone added without flattening the tooth

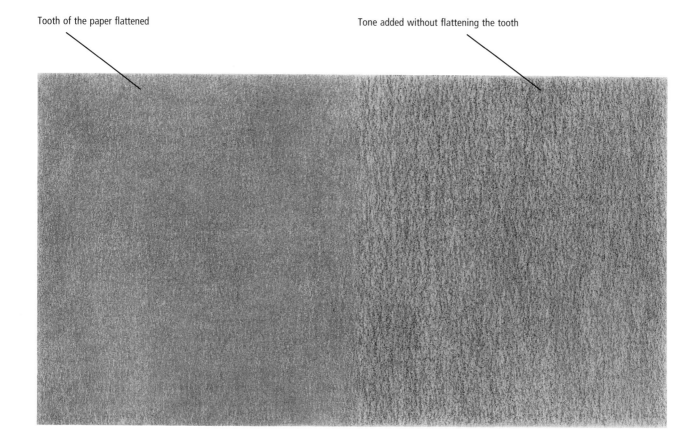

Miscellaneous Materials

Electric Pencil Sharpener

Sharpening pencils with a handheld or crank sharpener is possible, but when the blade becomes dirty or worn, it's difficult to keep the point of the pencil from breaking. This is especially true with charcoal pencils. It's worth the extra expense to invest in a good electric sharpener.

Sandpaper Block

Use this to refine the point on your pencil. Twisting the pencil while you drag it down the paper toward you re-sharpens the tip. It keeps you from using your pencil sharpener too much and wasting pencils. You can collect the excess graphite, charcoal or carbon dust on a piece of paper under the sandpaper block. Transfer these shavings to a film container, and use the powdered medium in your drawings with a paintbrush or a blender.

Tracing Paper

Inexpensive transparent tracing paper can be purchased even at most grocery stores. It should be durable enough to withstand heavy pressure with a sharp pencil without tearing. Mead Académie tracing paper is the brand I use.

Compass

This is handy for the occasional perfect circle, but I regularly use my compass to take measurements and check proportions.

Ruler

You'll need a ruler to use as a straightedge and for a measuring tool.

Drafting Tape

This low-tack tape sticks to paper but will not damage the surface when removed. Use it to attach drawing paper to a slanted drawing board and for masking straight edges.

Art Knife

This is a pointed razor blade connected to a pen-shaped handle. Its shape makes it easier to handle than a utility knife. Use it to cut shapes out of frisket for masking.

Frisket Film

Use this transparent masking film to mask areas you want to keep white while you render the surrounding areas.

Liquid Frisket

This type of mask can be used in smaller areas than frisket film. It's applied with a brush or a special applicator and removed by rubbing or peeling. Some brands stain the paper and are meant to be painted over once the dried frisket is removed. Use the type manufactured for use on watercolor paper in areas that will remain unpainted. I use the Grafix brand Incredible White Mask.

Fixative

This spray protects your drawing. There are several brands to choose from in both matte and glossy finishes. Workable fixatives reduce smudging, yet still allow you to add media and do some erasing. Nonworkable fixatives are permanent protective coatings made for your finished drawing.

Lightbox

If you use photographs for reference material, you should use a lightbox. It's amazing how much more detail is visible in the shadow areas. View the photo without the lightbox to see the most detail in the lighter sections.

Drawing Lamp

Many potentially great artists are hindered by their inability to see what they are doing. Even if the kitchen table is your drawing board, set up a desk lamp to illuminate your drawing surface. Place the lamp on the side opposite your drawing hand. This keeps the shadow of your hand from being cast on your paper.

Tips and Techniques

Before you sit down to draw a subject, there are many things to decide. Should a light background be used? Or would it have more snap with a dark one? Should the paper be smooth, or rough? Would it be better with charcoal? Graphite? Carbon? Or maybe a combination of all of them? It's enough to make you want to take up sculpting! Don't get discouraged—this chapter shows you some unique ways of handling drawing media to produce an assortment of effects you might not have thought possible. You still have to ask yourself all those questions, but once you know what each medium is capable of, the decisions are easier.

I am a self-taught artist, and I use many unconventional techniques in my work. The best advice I can offer you is this: Pay attention to your teacher. That means *you*. This book is merely the textbook you are using to teach yourself. Many of the techniques I demonstrate here I stumbled on by accident while experimenting with other methods. I encourage you to explore the material in this chapter, analyze your successes as well as your failures and learn from both.

. . . ONE BASKET
Charcoal and graphite on Arches 140-lb. (300gsm) watercolor paper
13″ × 11″ (32.5cm × 27.5cm)
Collection of Dr. and Mrs. Sunder Mehta

Keep Your Drawing Clean

One of the things I love most about working with charcoal and pencil is how easily it can be blended to create various shades of gray. One swipe of a clean cloth over some charcoal lines makes a beautiful progression of descending values arc across your paper. That's fine, if it's intentional. If the cloth is your shirt, and you've just produced what appears to be a smoking comet through the face of your latest commissioned portrait—you've got a problem.

Watch Those Hands

Some drawing methods require an extremely uniform texture, so irregularities in the paper can come back to haunt you. To begin with, try not to touch your drawing paper with bare hands. Wear cotton gloves, or make sure you pick the paper up by the edges where it will be trimmed or covered with a mat. Even if you think your hands are clean, your fingertips can transfer oil to the paper. This oil becomes apparent if it's in an area where you apply charcoal or graphite powder. It works exactly like fingerprint dusting powder, leaving perfect imprints of the person responsible for groping your paper. I find it impossible to make a smooth, even tone with charcoal or graphite powder in an area with fingerprints.

Upper Left to Lower Right

If you're right-handed, always try to begin drawing on the upper left of the paper and work to the lower right. This keeps your hand from smearing sections that are complete. It also keeps your hand from obstructing your view as the drawing progresses. If you're left-handed, work from the upper right to the lower left. Bear in mind, dark charcoal smears very easily—try to save it for last. If you *do* end up with charcoal next to a light area that still needs to be developed, a workable fixative can help keep the charcoal in place. However, it does change the texture of the paper wherever it's applied. Shown here are some other methods to keep your drawings clean.

Cover Completed Areas

When you *do* need to work on an area that requires your hand and arm to rest on a completed section, tape a sheet of clean newsprint paper over the area. The newsprint should be bigger than your drawing so it can be taped to your drawing board.

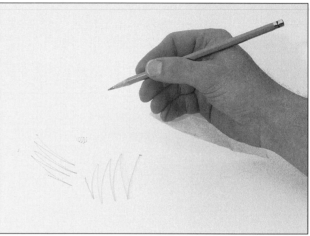

Create a Barrier

Tape a piece of slick paper on the side of your hand where it rests on the paper. This allows your hand to glide smoothly across the drawing paper and acts as a barrier to keep oil and dirt from transferring to the drawing paper.

Ways to Hold the Pencil

I've read many books on drawing that explain the proper way to hold a pencil, and they have been helpful for giving me ideas to try. However, I believe there are as many ways to do things as there are people. Each way of holding a pencil produces a different type of line. Learn to hold the pencil in a variety of ways, and you will have more tools at your disposal to create the tex-tures you desire. My theory is: If it works, use it. I'm right-handed, but to produce certain random marks on the paper, I've even held my pencil with my left hand and closed my eyes! Here are some of the ways I use most often. I'll refer to them in the demonstrations throughout this book.

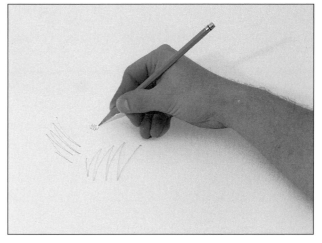

Underhand

I use this method, which uses wrist and arm movement to make long, fluid strokes with the side of the pencil. With your palm facing you, cradle the pencil between your middle and index fingers. Then, place your thumb on top of the pencil. Adjust the value of the strokes by varying the pressure with your thumb. Hold the pencil loosely and let its weight be the only pressure exerted on the paper to make extremely light, uniform strokes.

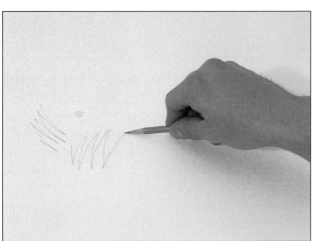

Overhand

Holding your pencil with your palm down like this keeps your wrist more stationary allowing your entire arm to do even larger strokes with the side of your pencil. I also hold charcoal, graphite and carbon sticks this way to create broad, sweeping strokes.

Modified Writing

Holding your pencil as if you were writing is good for detailed work. The only thing I do differently when drawing is to increase the distance between the pencil point and my fingertips. This per-mits more freedom of movement and a better view of my work.

Seeing the Light

Properties of light may seem obvious, but keeping them in mind can help you avoid many common mistakes. I find it useful to think of light as a measurable force that travels *directly* from its source to whatever I am looking at. The areas facing the light source are hit head-on, so they are the brightest spots. Places facing slightly away from the light are hit less directly and are not illuminated as brightly. Areas on the opposite side of the light source receive no illumination and fall into shadow. The intensity of light diminishes the farther it travels. This sphere shows the systematic changes of value called *chiaroscuro*. Since the Renaissance, artists have used this method to describe the effects that light and shadow have on a form. These are five elements that I refer to throughout this book.

Highlight

This is the lightest value seen on a form. It is most evident on smooth or shiny surfaces. It is actually the light source reflected back into your eyes. Use the white of your paper for all highlights and use smooth blending between the highlights and the adjacent values.

Halftone

This is the entire area on the form facing the light source. On this sphere, it is the area between the highlight and the core of the shadow. It gradually darkens in value as it turns away from the light source. A halftone can be rendered darker or lighter depending on the form's true color and lighting.

Reflected Light

This is light that bounces back into the shadow from surrounding objects. It plays a big role in making forms look three-dimensional. Be careful not to render reflected light too light. It should always be a darker value than any part of the form facing the light.

Core of the Shadow

This is the darkest value on the form. It appears as a band of darkness between the halftone and the reflected light. The core of the shadow gives many clues about the contours of the form, so it is important to render its shape correctly. It is a simple shape on a sphere, but on an irregular form—like a rock—the core of the shadow must be drawn to follow the contours of the underlying form.

Cast Shadow

This is the shadow cast by the form onto the ground plane or over other nearby forms. In general, cast shadow is darkest at the point next to the form where it originates. As it travels away from the form it becomes lighter in value. Cast shadows vary in intensity depending on the lighting conditions. Diffused light creates light shadows with soft edges while a concentrated light source produces dark cast shadows with crisp edges. Other value changes also can be seen in most cast shadows. In this example, I found that light was bouncing back into the cast shadow from the reflected light on the sphere. Scan the cast shadows of your subjects for subtle changes in value to add more realism to your drawings.

Highlight

Halftone

Core of the shadow

Reflected light

Cast shadow

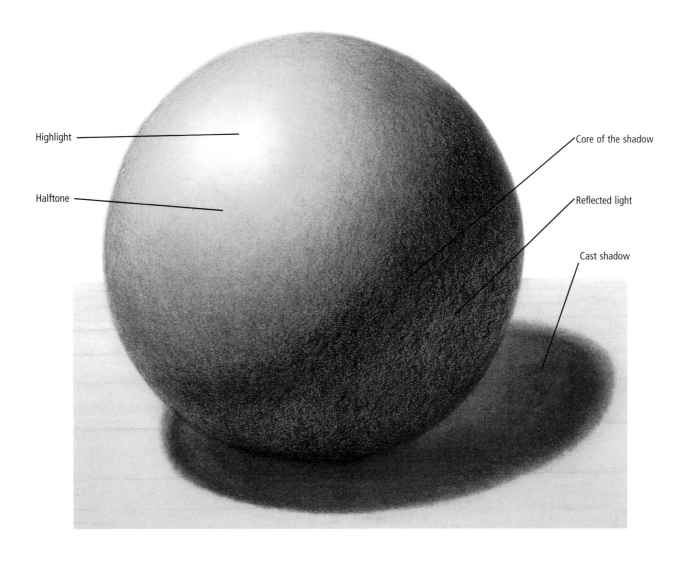

How Light Affects Texture

The texture of an object is more apparent when light strikes it at an angle. The more severe the angle, the rougher the texture appears. That's because the irregularities *protruding* from the form's surface face the light more directly, making them appear lighter than the underlying form. These protrusions also cast shadows onto the form. *Indentations* on the form receive less light, so they appear darker. However, the rim of an indentation that faces the light is brighter.

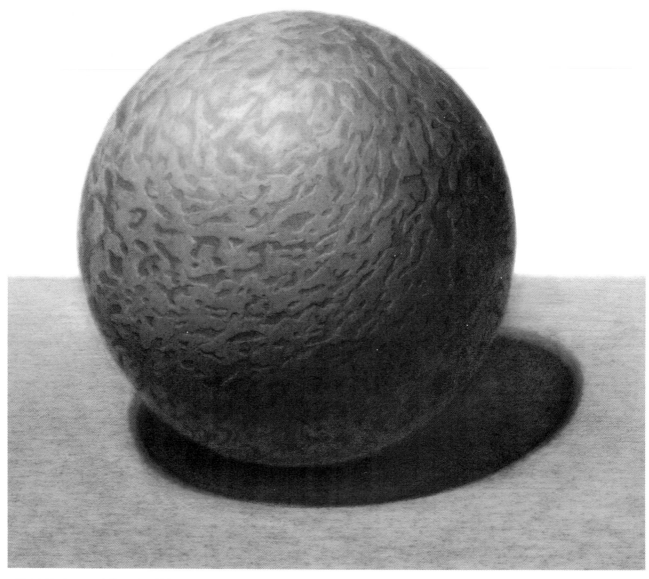

Light, Texture and Changing Values

The texture on this sphere is more prominent near the core of the shadow. This is where the light strikes the edge of the raised surface irregularities at the most oblique angle. In my drawings, I sometimes exaggerate this principle of light to accentuate textures in this area beyond what I see in my models. This gives a feeling of heightened realism.

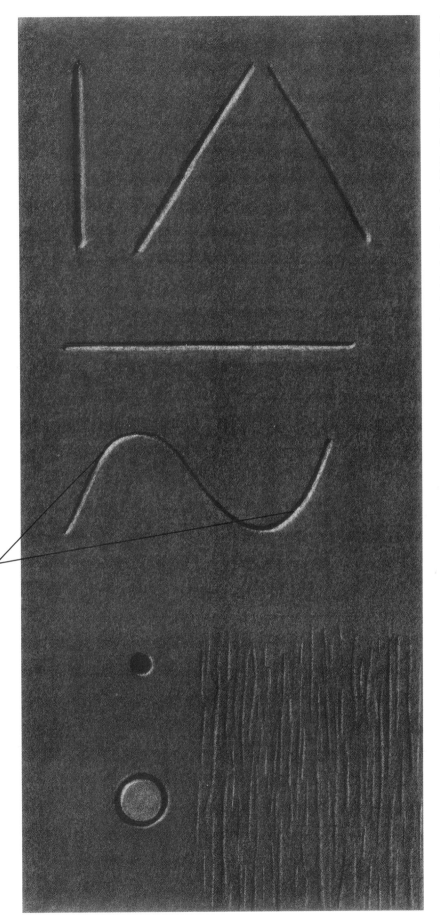

The Lighter Side of a Depression

Cracks, indentations, grooves or depressions in a flat surface receive less light. But if the outside rim of the depression faces the light source, the rim will appear lighter than the surrounding surface. In this example the light comes from the upper left, making the right side of each groove lighter.

The edge of a recessed area is brightest where it is perpendicular to the light source.

Basic Strokes—Value

In my realistic drawings, I emphasize value and texture more than visible lines. The initial strokes are sometimes hard to see in the finished piece. They are blended, erased or manipulated to create the look of a specific texture in the subject. These demonstrations show you some of the beginning strokes you need to know before we get into the really fun stuff. Remember, you can't play jazz until you know the scales!

To make an object look as three-dimensional as possible, the tonal values must be rendered accurately. There are many methods of shading drawings to create values. I use different hardnesses of pencils for various shades of gray and directional lines placed very close together. My strokes follow the contour of the subject to help indicate its form.

Follow the Contours of the Subject
When shading a drawing, the direction of the value strokes help define the subject's form. I followed the shape of the top and bottom ellipses when I shaded this clay pot.

The Wrong Way
This is the subject drawn with the same values. It lacks the sense of roundness that is evident in the first example because the strokes don't follow the contours.

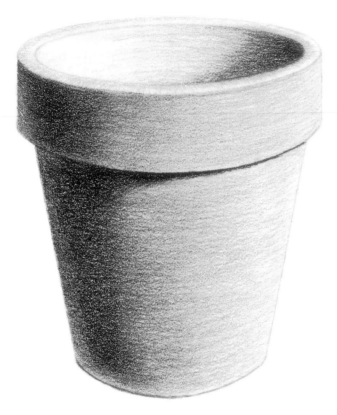

Circular Shading Method
Another way to make smooth value changes begins with drawing small circular shapes, as shown on the left of this square. Overlapping the circular shapes, using more pressure, using softer pencils or using a combination of these three methods darkens the values.

Gradually Changing the Values

Most subjects have areas that gradually move in and out of the light. So, you need smooth transitions from dark to light in your drawing. One method is to systematically apply more of the drawing medium in shadow areas and less in areas that receive more light. Use progressively longer and lighter strokes leading from the shadow to the light to do this. The most important thing to remember is to make sure all the strokes begin in the darkest area of the subject.

1 Shadow Side First
Lightly outline the shape. Place drafting tape on the left edge so you can make smooth strokes without worrying about shading outside of the lines. Using a soft 4B graphite pencil, start at the top and apply short strokes—from left to right—down the length of the shadow side. Make these lines close together or slightly overlapping. Next, starting in the same place, apply longer strokes using a slightly harder pencil. I used a 2B. Pay attention to the contours. Notice the bottom ellipse is rounder than the top. It's easier to make smooth, flowing lines if you use lots of arm motion and hold the pencil either overhand or underhand, as described on page 19.

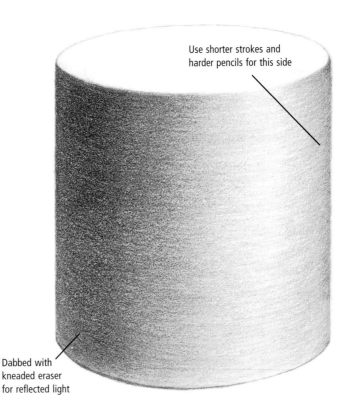

Use shorter strokes and harder pencils for this side

Dabbed with kneaded eraser for reflected light

2 Add Longer Strokes
Starting in the extreme upper left and working down, keep adding longer strokes with slightly harder pencils as you make your way across the form. This darkens all of the values at once, so make sure you don't build up the dark areas too fast. It's easier to add strokes to keep the transitions smooth than to erase them if an area is too dark.

3 Go Toward the Light
Repeat the previous step until the longest strokes approach the lightest area. By now, you should be using a fairly hard pencil—like a 6H. If you notice abrupt transitions, go over them again with a softer pencil—just remember to begin the strokes in the dark area of the shadow.

Basic Strokes—Textural

This book would be as long as *War and Peace* if I tried to explain exactly how to imitate every texture. The key to simulating texture begins with identifying its most noticeable characteristics. If possible, close your eyes and feel the subject. This gives you a better understanding of its surface quality and helps you decide which medium would work best to imitate the texture. Textural strokes made with charcoal create a distinctly different texture than strokes of graphite or carbon. For these demonstrations, experiment with all three and note the differences.

Begin the first series of strokes here.

Gradually move your arm down while keeping the same stroke length.

1 Texture With One Value
Hold a medium charcoal pencil with the modified writing method and start in the upper left to make a smooth, even texture with no value changes. With light, even pressure make downward vertical strokes approximately an inch (2.5cm) in length. Now, raise your pencil and slide your arm down the paper about ⅛″ (0.3cm) so your second set of strokes begins ⅛″ lower than the first and adds ⅛″ to the line. Try to use a fluid motion. Move your hand rhythmically, as if gently whipping an egg with a fork. Continue moving your arm slowly down the paper, making sure the overlapping looks even. Lift your pencil as little as possible when you bring it up for the next stroke to keep the value of the stroke consistent.

2 Moving Across the Paper
When you reach the bottom of the section, move your hand back to the top. Slightly overlap the lines from step one and apply the strokes down the page again. Repeat this until you have covered all the area evenly. Depending on the final texture you want, the technique could end here. For example, since it leaves a hint of a directional line it can be used as the first step to draw convincing wood grain.

3 Cross-hatching
Turn your paper so your hand is in a comfortable position to do strokes perpendicular to the previous ones. If your hand touches the area previously covered with charcoal, cover that part of the drawing with a piece of newsprint. Apply strokes diagonally in both directions, so every inch is covered with lines going four different directions.

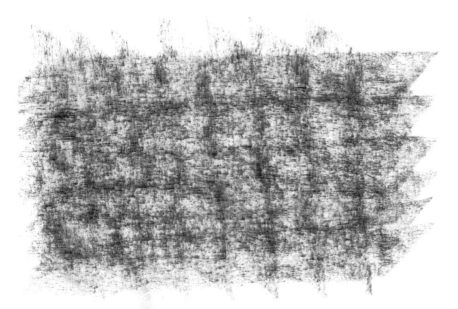

Patterned Texture With Sticks
Another way to block in a large area with texture is with the broad side of charcoal, carbon or graphite sticks. Here I used cross-hatching with a medium vine charcoal stick.

Random Texture With Sticks
You can also use sticks to produce a wide variety of textures without directional lines. Here, I used overlapping circles and figure eights with a medium graphite stick. This can also be blended and reapplied to produce a smooth, dark texture.

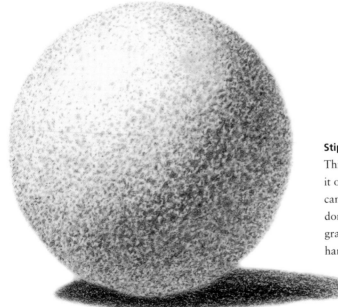

Stippling
This technique is most commonly used with pen and ink, but I use it often in my charcoal and pencil drawings. It creates a look that can't be duplicated any other way. Stippling is produced by randomly placing dots on the paper. For the values here, I used a soft graphite pencil and more dots for the dark side of the ball and a hard pencil with fewer dots for the light side.

Blending Techniques

Blending materials are as indispensable as pencils. I wouldn't dream of doing a drawing without them. The most common blending materials are tortillons and stumps. These are used to model form by making smooth gradual transitions from dark to light. But that's not all they are good for. I use these, plus other blending materials, to apply and remove the medium, soften hard edges and smooth out unwanted pencil strokes. A good reason to use a variety of blenders is that each performs these jobs differently while applying specific textural effects.

It's useful to know each blending tool's particular characteristics to help you choose the one that will help you achieve the look you want. I like to let the materials work *for* me rather than spend time and effort fighting their inherent traits. Also keep in mind that the texture of the paper, the hardness of the pencil and the amount of pressure used to make the initial marks all affect the outcome. With so many variables, the textural possibilities are endless!

Blending Comparison

Each blending tool on the opposite page was used under the same conditions to help compare their attributes fairly. This comparison was done on the backside of Arches 140-lb. (300gsm) watercolor paper. The dark vertical strip was made with a 4B charcoal pencil. With each blender, I made twenty circular strokes through the strip followed by ten swipes emanating from each circle.

A lot can be learned from studying this comparison. The circular strokes show each blender's ability to soften the initial charcoal strokes and pick up charcoal. The blended arcs originating at each circle indicate how quickly the charcoal dissipates from the blender and the type of texture it can make when used as the drawing medium.

Do Your Own Comparisons

Do some blending comparisons like the ones here using various types of paper, pencils and blenders. Label and save the most diverse ones for textural reference material. Experiment with other items to use as blenders, such as smooth and rough fabrics. You never know when you might come across something that will produce a unique texture. Just make sure your blending materials are clean and the color from dyes won't rub off on your paper. I don't recommend blending with your fingers since that can transfer oil and dirt to the surface of your paper.

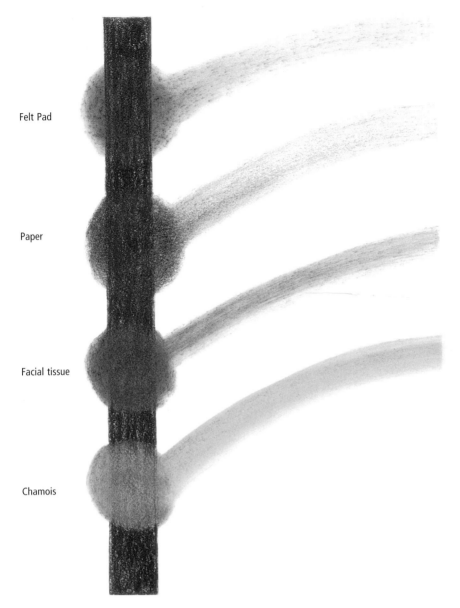

Felt Pad

This is one of my favorite blenders because of the interesting textural effects it seems to make by accident. When you use a felt pad to *apply* the medium, it's important to consider the direction of the strokes since tiny dots and dashes are dispersed in the direction you move the felt. Use this to your advantage in replicating coarse textures that have directional lines, such as wood and denim. Circular blending produces a bumpy look that can be used to simulate the texture of irregular surfaces. Use a kneaded eraser to bring out light spots next to some of the bumps to give more depth.

Paper

Blending with paper brings out the texture of the drawing paper. Use it for undefined background textures and to separate two objects with similar values by using texture only. The paper you use to blend with makes a difference in the texture created. I wrapped notebook paper around my finger for this example.

Facial Tissue

The original charcoal strokes are barely visible in this circular blending. Compared with the felt and paper blenders, facial tissue is very good at softening unwanted strokes. I also use it to blur the edge of shadows and to lift the medium to simulate reflected light. Paper towels are a better choice if you don't want to lighten the area as much. Facial tissue retains the medium well and distributes a moderately smooth dark value.

Chamois

To imitate smooth textures like skin tones and reflective surfaces like glass I have found nothing better than a chamois. Use it like an eraser to lighten large masses of dark charcoal. If a texture created by one of the other three blenders is too harsh, blending lightly with a chamois softens it. The value at the beginning of the arc is only slightly darker than the end, which means it retains and disperses the charcoal more evenly than the other three blenders.

Blending With a Chamois in Small Sections

Stumps and tortillons usually work fine for blending small sections, but occasionally you'll want to produce a softer texture than they are capable of. The delicate shading in the white of an eye is one example. Simply rolling the chamois makes spirals on the tip that will not glide across your paper evenly. By folding the chamois and rolling both sides to the middle, you can make a small, smooth blender. Felt pads can be rolled in the same manner.

1 Fold the Chamois
Start by finding a clean edge on the chamois. Then, take the top corners and fold them down to form a point at the clean spot.

2 Roll to Form the Tip
Starting at the tip, roll one of the folded edges until it reaches the middle. Roll the chamois tighter towards the tip to make it firm.

3 Roll the Other Side
Do the same with the other side. Make sure you don't roll past the tip or it will create coils on the bottom of the chamois, making it impossible to blend evenly. To use the blender, hold it with the rolled edges on top. This allows the smoothest surface to touch your paper.

Blending Values

In most situations, you blend from the dark values to the light to create the illusion of form. The more you blend the darker the halftones get. If you overblend, you need to gradually lighten the halftone values. Working from light to dark, use a clean chamois to gently lift the medium. Use light strokes in the same direction the medium was applied. As the chamois becomes loaded with the medium, it will deposit it again with each stroke. To avoid this, fold the chamois to a clean section often.

Blending Toward the Light

These graduated values are made with 3B, B and HB charcoal pencils. They are blended from left to right with a stump in the same direction as the pencil strokes. The halftones on the right have become too dark because of overblending.

Blending From Light to Dark

Here, a clean chamois was used to lift the charcoal and blend from light to dark. The same rules apply when blending from dark to light—follow the contours of the form and the strokes when you blend.

Combining Blenders

The texture produced with a blender can be altered by using another blender. For instance, the random dots and dashes created by blending with a felt pad can be eliminated by first blending the charcoal with a stump. Combining blenders like this produces a different texture than blending with either blender alone.

Combining Blenders
These are strokes of 3B charcoal blended across the paper with felt. The result is a bumpy, irregular texture.

A smoother texture can be created by first blending the charcoal with a stump and then using the felt.

Real and Perceived Textures
There are two kinds of texture in drawing, *perceived texture* and *real texture*. I use both to add realism to my drawings. Perceived texture uses light and shadow to give the *illusion* that the object contains texture. Real texture is the *actual texture* produced by applying the medium to the paper. Real texture is influenced by the hardness of the pencil and the tooth of the paper. Tones made with softer pencils create rougher textures. The surface of the paper can be altered to form new textures by creating indentations or by flattening the paper's tooth. The three drawing media I use also produce dissimilar real textures on the surface of the paper.

Uses for Charcoal and for Graphite

Charcoal

I use charcoal for the darkest values of my drawings. The individual granules of charcoal have an irregular shape. When light strikes a drawing containing these particles, it bounces back in many different directions. That means when it's pushed to its darkest value, charcoal does not have the reflective glare that is common with graphite. The darkest values in drawing are the shadows, and, if you are trying to render a subject as realistically as possible, the last thing you want is a shadow that reflects more light than the subject does.

Because of the size and shape of the charcoal particles, tones produced with charcoal appear rougher than those made with graphite. Consequently, charcoal is best suited to draw subjects with more texture. Soft charcoal produces rougher texture than harder charcoal. When you look at your subject, pick out the features with the roughest textures. If you use charcoal to render those areas, you will create a much more realistic drawing. Subjects I typically render with charcoal:

- Wood
- Bark
- Fur
- Hair
- Eyelashes
- Pupil of the eye
- Dark line between the lips
- Coarse fabrics, like denim
- Leather
- Cast shadows

Graphite

I use an F graphite pencil to do the initial layout of my drawings. The lines are dark enough to see yet easily removed with a kneaded eraser. For rendering, graphite can produce much more delicate textures than charcoal. You can achieve extremely subtle value changes with graphite by applying it directly with blenders or brushes. The individual particles of graphite are flat. This causes light to reflect off the graphite in your drawings. Take advantage of these inherent qualities, and render all smooth and shiny subjects with graphite. Subjects I typically render with graphite:

- Skin tones
- Shading in the white of the eye
- Glass
- Porcelain
- Light tones in shiny metal
- Smooth fabrics
- Light shading on paper objects

Using Charcoal Adjacent to Graphite

Because charcoal and graphite reflect different amounts of light, when an object rendered with graphite is adjacent to charcoal in a drawing, the graphite object appears to pop forward. Let this work to your advantage by using charcoal to render cast shadows and backgrounds. The charcoal creates a dense black with no glare, and the shadow or background touches at least a portion of the object, which is often rendered in graphite.

Blend Charcoal Into Graphite

Although charcoal and graphite produce different textures and have different reflecting qualities, they can be mixed together. The dark values of charcoal can be gradually blended into the light tones of graphite. This technique is good for subjects that gradually turn away from the light. Since the *texture* of a curved form is more visible as the shading approaches the core of the shadow, using charcoal to render that area automatically adds more texture.

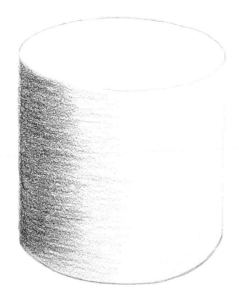

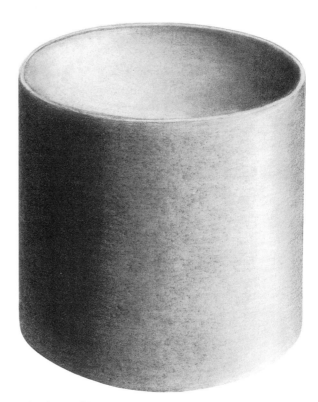

1 Blend Charcoal Into Graphite
Begin by applying 3B and B charcoal to produce progressively lighter values as the form turns toward the light. Use the darkest strokes to form the core of the shadow.

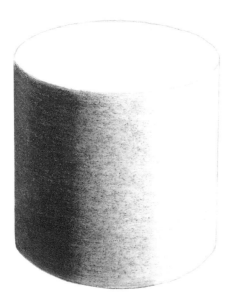

2 Blend With Felt
Use a felt pad to blend the charcoal toward the light side of the form.

3 Apply Graphite
With long sweeping strokes, apply F graphite over the form all the way to the highlight. Then, blend with felt to form the smoother texture next to the highlight. Try not to pick up more charcoal on your blender, because that produces more texture. On the right side, layer F graphite over B charcoal, and blend with a felt pad toward the highlight.

Layer Graphite Over Charcoal

Charcoal is capable of much darker values than graphite. Smooth subjects—such as glass and metal—often have high contrast. To render this texture realistically, you need the darkness of charcoal plus the reflecting qualities of graphite. You can apply graphite directly over charcoal to achieve a remarkably smooth, dark, reflective texture. Apply the charcoal first. Since graphite particles are flat, they tend to be slick, which makes it difficult to render charcoal *over* graphite. To keep the texture smooth in the lighter sections of reflective surfaces, use graphite alone.

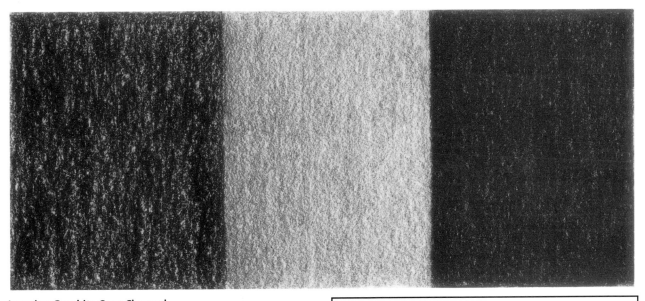

Layering Graphite Over Charcoal
As this example illustrates, layering graphite over charcoal produces an entirely different effect than using either medium alone. The first section is HB charcoal. The next is 4B graphite. The smooth, dark section is 4B graphite layered over the HB charcoal.

Light-Reflecting Qualities
All of the illustrations in this book have been photographed from directly in front of the drawings. This eliminates the light-reflecting qualities that are apparent in my original work. If you use the media specified to do the step-by-step exercises, your drawings will also take on this added dimension. By moving slightly to one side of the example, you can see the reflecting quality of graphite layered over charcoal. Blending the layers of charcoal diminishes the amount of reflection.

Using Charcoal and Graphite Powder

You don't need to purchase expensive charcoal and graphite powder in art supply stores because you inadvertently create it every time you sharpen your pencils. You can collect large amounts of the powder from your sandpaper block and store it in a film container.

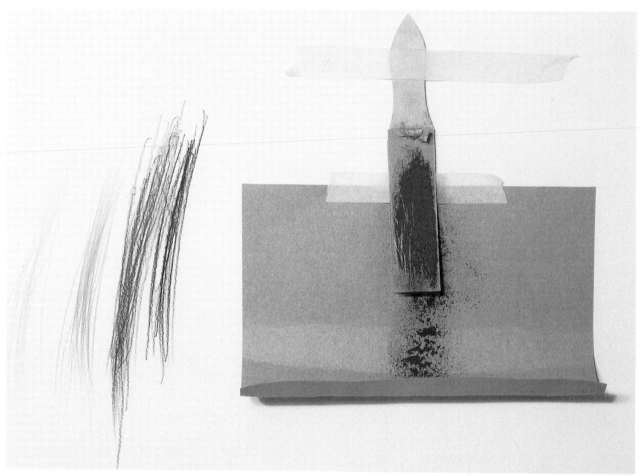

Collecting Charcoal and Graphite Powder

On the right in this photo I show how you can curl the bottom edge of a piece of paper to form a trough to catch charcoal and graphite powder. Tape the paper to one side of your drawing board. Next, tape the sandpaper block on the paper and tape it down. To store the collected media, carefully remove the paper and empty it into a film container.

You can also refine your pencil points on paper taped to your drawing board. The pencil lines left behind can be used to load blenders with the drawing medium. This method works best for smaller areas since it is easier to control the amount of medium loaded on the blender.

Charcoal and Graphite Powder Are Messy

Use care when working with charcoal and graphite in powdered form. Here are a few tips:

- Do not place your sandpaper block directly above your drawing. That would be a disaster just waiting to happen!

- Be extremely careful when you remove the paper from under the sand block. One crinkle of the paper—or, heaven forbid, a sneeze—will send it flying everywhere.

- Unless you want to look like a chimney sweep, move your drawing to a flat surface before you pour powdered media onto your drawing.

Rubbings

Rubbing is an old technique used to obtain an impression of a textured surface on paper. It's useful to create various textures in drawings that would be time-consuming—if not impossible—to produce any other way. To produce a rubbing, secure your drawing paper to an object that has a raised or incised texture. When the drawing medium is *rubbed* onto the paper, it transfers the imprint of the texture to the paper. Many things affect the look of the imprint. The lighter weight the paper, the more texture is transferred. For a good transfer, the paper should be no heavier than 140-lb. (300gsm) watercolor paper. The type and hardness of the medium also alters the texture. I find that using the broad side of a charcoal or graphite stick works best, because I can cover a large area without worrying about conflicting directional lines. A different effect is created by applying the medium directly with a blender.

The rubbing does not have to be the finished texture in your drawings. It can be used as a foundation on which to build other textures by adding shading and picking out highlights. Try rubbings of various textured objects you find around the house. Then, pick out highlights and add shading to embellish the texture.

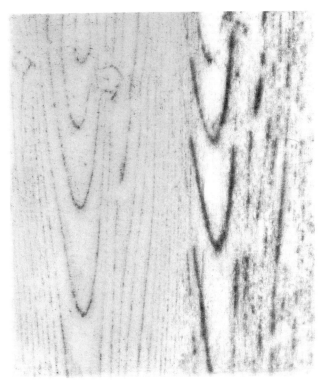

Changing a Rubbing's Effect by Changing the Medium
Using different media and application techniques changes the texture of a rubbing. This is 140-lb. (300gsm) watercolor paper taped to an old piece of wood. On the left, B graphite was applied directly with a piece of felt. On the right, no. 2 vine charcoal was applied with the broad side of the stick.

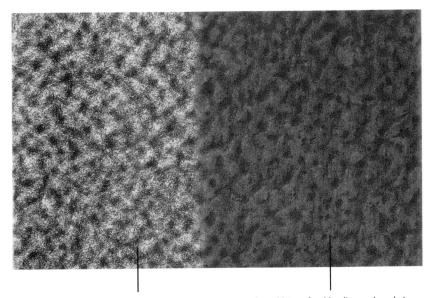

Direct result of rubbing The rubbing after blending and rendering

Altering the Rubbing
A completed rubbing can be manipulated to produce more textures. This shows a rubbing before and after it has been rendered. I attached 140-lb. (300gsm) watercolor paper to the bumpy texture of a tile on my kitchen table. The broad side of a 6B graphite stick was used to make the rubbing. While the paper was still attached to the tile, I blended the right side with a stump. Then, I moved the paper to my drawing board and refined the texture, lifting the graphite with a kneaded eraser in the lighter areas and blending the darker tones with a tortillon.

Indenting

Many subjects call for small, crisp areas of white surrounded by darker values. Many times people attempt to handle this problem by avoiding the white while they render the surrounding darker values, or by trying to erase back to white after the dark values are complete. Neither of these methods works well. Even erasing with an eraser pen leaves some medium on the paper. This simple technique creates thin lines of white surrounded by darker values. Use it in areas that are too small to mask with frisket. These are some of the areas for which I regularly use the technique:

- Stitches in fabric

- Splinters in wood

- Pits and scratches in metal

- Cracks in leather

- Sharp edges of broken glass

- Animal whiskers and white fur

A Happy Accident

I discovered this technique by accident years ago. It is a perfect example of learning from your failures. I was using tracing paper to transfer a sketch onto my drawing paper. Things were not going well, and I was irritated when I had to begin again for the third time. Apparently, I took it out on my drawing paper because when I lifted the tracing paper, I noticed little grooves where I had pressed too hard with my pencil. I didn't think it mattered since the indentations would be covered with charcoal. But when I rendered the subject I noticed as the paper got darker, the grooves stayed white and appeared even *more* striking. I had ruined the drawing again, but I decided I should at least try to make use of what I had discovered. Since then, I have seen colored-pencil artists use a similar impressing technique and always wonder whether they also learned it the hard way.

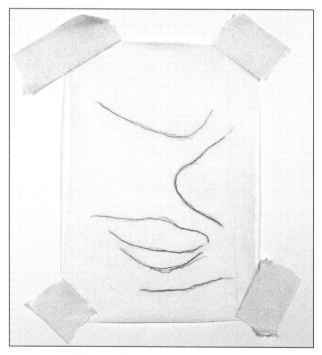

1 Cover with Tracing Paper
Tape a piece of tracing paper to your drawing paper. If you are using a lightweight paper, place several pieces of scrap paper underneath to make it easier to indent. The lines on the tracing paper are guidelines to tell where the major value changes will be in the wrinkled material.

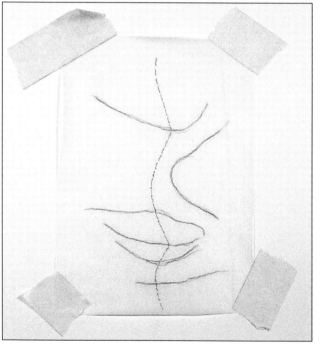

2 Make Indentations
Use firm pressure with a 6H graphite pencil to draw the stitches. Push hard enough to make impressions in your drawing paper. To keep from tearing the tracing paper, use a pencil with a rounded point and *pull* it down toward you—rather than push it.

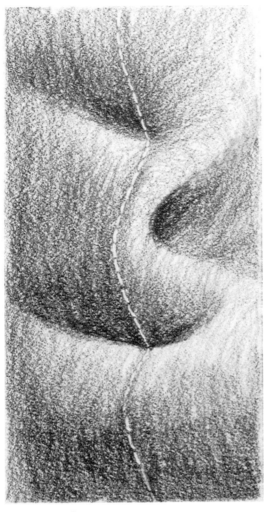

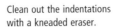
Clean out the indentations with a kneaded eraser.

3 Apply Charcoal
Remove the tracing paper and use a B charcoal pencil to apply the values. Make sure you follow the contours of the folds with your strokes.

4 Blend and Develop the Values
Use a stump to blend with the contours of the wrinkles and a 3B charcoal pencil to darken and refine the values. Then, twist the end of your kneaded eraser to a point and clean out the grooves where the stitches receive the most light. Finally, define each stitch by making a hard edge next to the indentations with a sharp HB charcoal pencil.

Modifying Indentations

Occasionally, indenting the paper doesn't create the hoped-for effect. This is not obvious until you apply charcoal or graphite over the impression. Fortunately, you can modify and even eliminate the white lines that were produced.

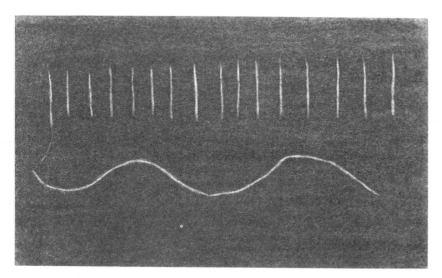

Modifying Indentations

I produced these white lines by placing tracing paper over my drawing paper and using firm pressure with a 6H graphite pencil. Then I applied 3B charcoal and blended with felt.

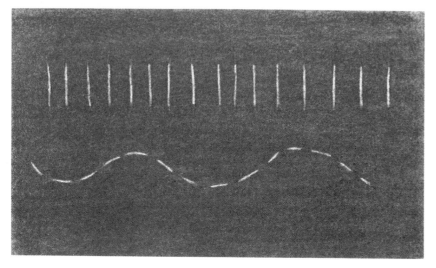

For the lines on the top, I filled in sections of the grooves with a sharp HB charcoal pencil to make them all the same length. Then I blended those areas with a small stump. The curved line on the bottom was transformed into a series of dashes using the same method.

Random Indentations

When white lines need to be precise, the "hard pencil and tracing paper" method is ideal because it creates uniform indentations. For imitating other textures—like rock—you achieve a more realistic look if the indentations vary in size and shape. Any clean stylus can be used to make irregular, high contrasting spots of white—as long as the stylus *pushes in* the paper without cutting or tearing it. Use the stylus directly on your drawing paper with no tracing paper barrier. I have used nails, coins, paper clips, empty ink pens and even rocks to make irregular indentations.

Masking With Frisket

Masking is generally known as a painting technique, but it is also an effective way to produce clean, crisp edges in your drawings. It allows you to protect foreground objects from unwanted media while you render backgrounds and adjacent subjects.

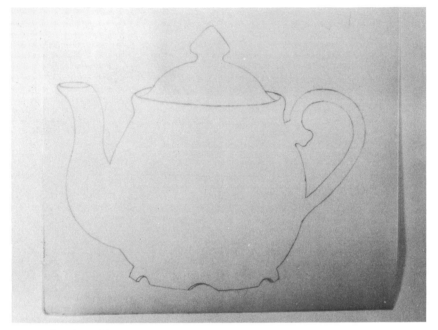

1 Outline the Subject
Begin by drawing the outline of your subject directly onto a piece of frisket film. Make sure you draw on the film side and not the backing, or you will end up with a reverse image of your subject.

Two Ways to Apply Frisket Film
There are two ways to use frisket film: (1) Cut out the shape with an art knife and then apply it to your drawing, or (2) apply the frisket to your drawing, cut the shape you need and remove the unwanted frisket from your drawing. I use the first method. The surface of your drawing paper can easily be damaged when you cut the mask *after* it is attached—and many times, I have already put in too many hours to risk that.

Hints for Cutting Frisket
Make sure your cutting surface is smooth. Irregularities affect the quality of your cuts. A self-healing cutting mat works, but for a supersmooth cutting surface, try a piece of glass. It wears out the blades faster, but I find it easier if the blade doesn't cut into the underlying surface. The cleanest cuts can be made by pulling the knife toward you. To cut rounded shapes, *rotate the frisket* on your cutting surface while pulling the blade toward you. Use a straightedge to cut areas of your subject that have perfectly straight edges.

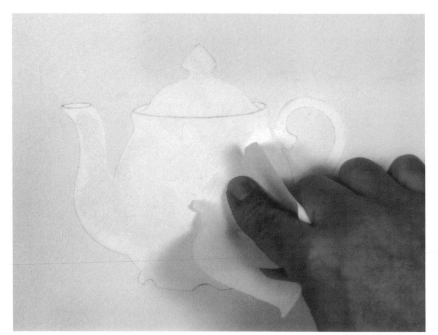

2 Cut Out and Apply the Image

Use an art knife to cut out the image. Then, peel off the adhesive backing. Always hold the peeled frisket with the sticky side up to keep it from folding together and sticking to itself. Next, attach the silhouette to your drawing paper. Use the slick side of the frisket backing to make sure the edges are securely tacked down and to force out any air bubbles.

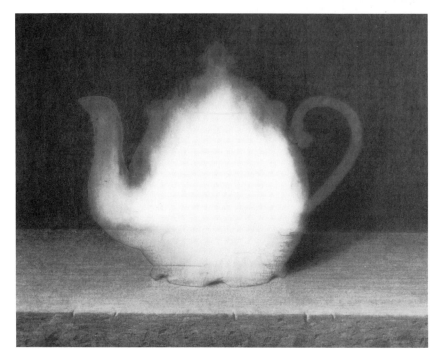

3 Render the Rest of the Drawing

Now that your subject is protected you don't have to worry about keeping it clean while you render the background and other elements of your drawing. Here I used layers of 3B charcoal for the background and blended HB charcoal for the texture of the old shelf.

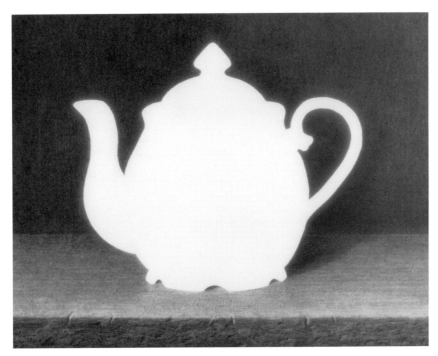

4 Spray With Fixative

If you use graphite to render a subject with a smooth texture—like this teapot—you will need to keep the charcoal from smearing into it. To help keep the charcoal in place, spray your drawing with several coats of a workable fixative *before* you remove the frisket. When the fixative is dry, peel off the mask to reveal the clean white silhouette of your subject.

When to Use a Fixative

Since using a fixative alters the texture of your drawing paper, you can spray it *after* you remove frisket to produce a totally different texture. Subjects that have more texture and require less separation from the background can be rendered without using fixative. To avoid unwanted smears, make sure you cover the completed areas of your subject and background with another piece of paper.

Draw Realistic Objects

Now that you understand the techniques used to create dramatic contrasts and interesting textures, you can put them to work to render subjects more realistically. In this chapter, I demonstrate how I render a variety of subjects. Certain distinguishing characteristics help identify every object. These are the traits that make glass look like glass, leather look like leather, etc. Rendering the texture of an object boils down to successfully imitating its most distinguishing characteristics.

I hope this section also helps you to think on your feet. Don't follow the captions like a recipe book without regard for the outcome on your paper. You need to use your knowledge of the media and techniques but most of all, your *eyes*. The letters that delineate the degree of pencil hardness are contained in the captions, but use them as basic guidelines. Remember, a variety of values can be produced by adjusting the pressure applied to the pencil. To reproduce the values as you see them here, you may need to adjust pencil pressure or use slightly harder or softer pencils. The amount you need to layer and blend may also vary, so check your values and textures before proceeding to the next step.

Also keep in mind that I adjust values and shapes throughout the drawings. Look and read several steps ahead to see where I end up, instead of becoming bogged down in one particular step.

MASON JAR AND BRUSHES
Charcoal, graphite and carbon on Arches 140-lb. (300gsm)
watercolor paper, 17″ × 9½″ (42.5cm × 23.8cm)
Photo by Richard Stum

Drawing Metal

The textures of metal objects are varied. Metal can be rough and pitted or smooth and reflective. I use totally different methods and media to render each. All types of metal can be rendered realistically using charcoal, graphite, carbon or a combination of all three. The secret is in knowing the special characteristics of the three types of pencils, and letting them work for you.

Old Pitted Metal

The technique of indenting the paper works well to indicate scratches and pits in old metal. I often use a Wolff's B carbon pencil to shade over the impressions I make in the paper. Carbon pencils get as dark as charcoal but reflect more light. Therefore, when carbon is adjacent to a charcoal background or another object rendered with charcoal, it seems to have more *presence* and come forward in the picture. Charcoal or graphite may also be used to render old metal. Depending on your subject and background, either of these may be a better choice.

Bad Luck or . . .
A horseshoe hanging upside down is said to be bad luck, but here it is just an illusion. You are *fooled* into believing you see the symbol for bad luck, just as you are *fooled* into believing in the superstition.

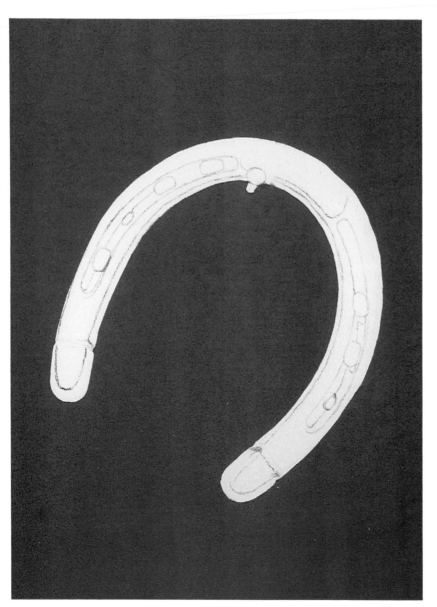

1 Mask the Horseshoe Shape
Cut the horseshoe shape out of frisket, and attach the silhouette to your paper. Use the broad side of a soft vine charcoal stick to apply a medium dark value for the background. Spray with a fixative and then remove the mask. Lightly sketch the nails and the inner contours of the horseshoe. Next, use tracing paper and a 6H graphite pencil to make numerous indentations in the paper that will resemble light reflecting off the pits in the metal. Look at step 2 to give you an idea of the size and amount of stippling to use. Concentrate the indentations in what will be the darker values of the horseshoe.

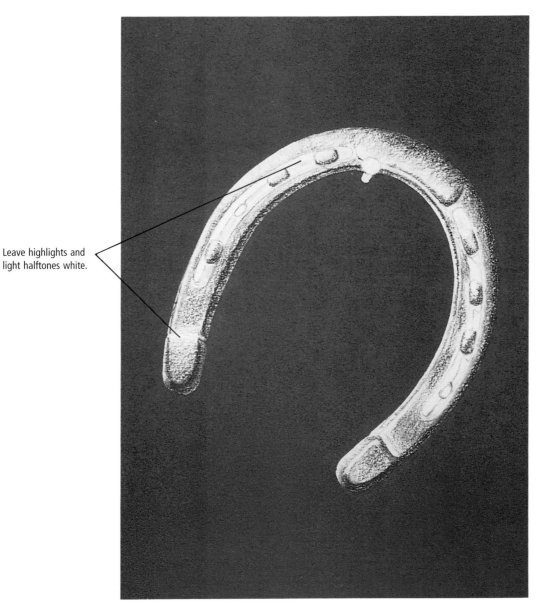

Leave highlights and
light halftones white.

2 Add Tone

Use a Wolff's B carbon pencil to tone the drawing. Leave the pencil point dull so the carbon skips over the indentations in the paper, leaving them white. Use more pressure for the darker values, and stay away from light halftones and highlights.

Apply Workable Fixative
Use a *workable* fixative before rendering the horseshoe. It provides the workable surface you need to apply additional charcoal for the cast shadow.

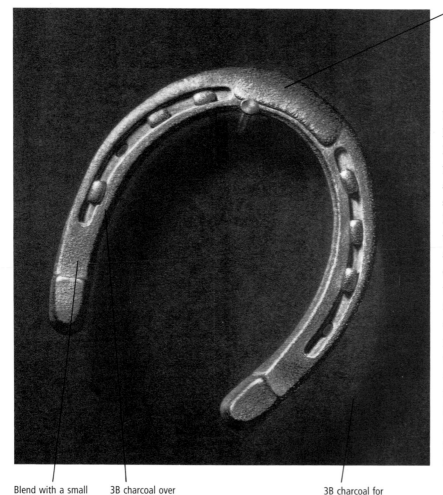

Blend with a tortillon

3 Blend the Carbon

Use a small paintbrush and tortillon to blend and fine-tune the textures of the horseshoe. Apply HB charcoal with a tortillon for the smooth, light halftones. Use your kneaded eraser to keep the highlights and light halftones clean. Darken the shadow on the inside of the horseshoe by layering 3B charcoal over B carbon. Render the nail using Wolff's B carbon for the shaft along with F and 6B graphite for the head of the nail. See pages 82-85 for more detailed information on rendering nails. Finally, use a 3B charcoal pencil for the cast shadow, and soften the edges with a small paintbrush. To produce the roughest texture, don't blend the carbon with anything after it is applied. This keeps the indentations white. Soften the texture by blending lightly with a small paintbrush. Blend with a stump or tortillon to mute the effect of the impressions more or to produce less texture.

Blend with a small paintbrush

3B charcoal over Wolff's B carbon

3B charcoal for cast shadow

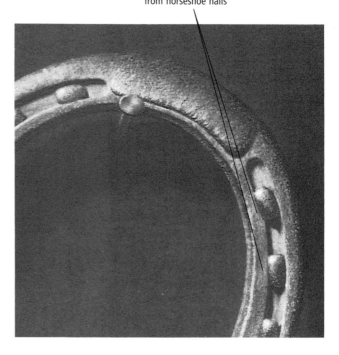

Reflected light from horseshoe nails

Close-up of Right Side of Horseshoe

Watch closely for areas of reflected light. They can be subtle, but when they are included they help carry your drawing to a higher level of realism. Here, light bounces off the horseshoe nails back onto the front of the horseshoe.

Reflective Metal—Three Coins

High contrast is the key to drawing bright reflective surfaces. This makes graphite and charcoal perfect for shiny metal. Graphite is the most reflective of our three media, so I use it for all the reflections and charcoal for cast shadows. For dark reflective areas, charcoal can be applied first, followed by the graphite. Since the paper is your lightest value, save it for the highlights on the metal.

When you set up a scene to draw, keep in mind that the appearance of reflective metal, such as a silver goblet, is affected by its surroundings. It is essentially a distorted mirror reflecting everything around it. You can use this to your advantage by placing other still-life objects in positions that make it easy to identify and draw their reflections. It's also a good idea to identify everything that is being reflected in your studio before including it in the drawing. You don't want to get halfway through and discover the reflection you're drawing is the dirty laundry wadded up in the corner of your studio.

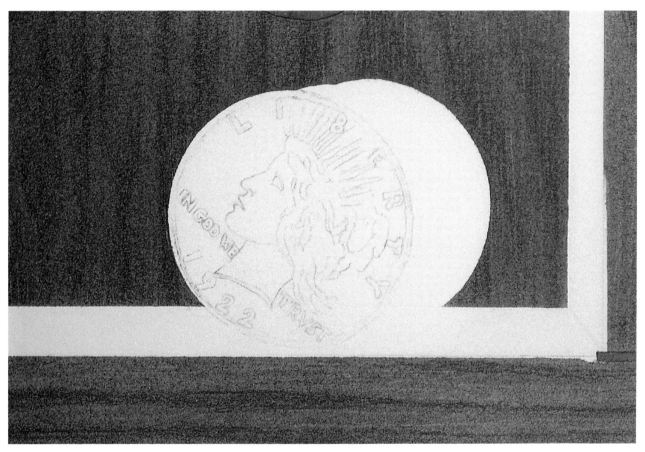

1 Mask a Silhouette of the Coins
Mask the coin shapes and the ledge they sit on. Then, apply 2B charcoal and blend with a stump. Spray the area with a workable fixative to keep the charcoal from smearing. Then remove the mask. Using a sharp 2H graphite pencil, begin *lightly* outlining the details of the coins to get the proper placement of all the elements. If you press too hard, the details on the coins will appear more drawn than raised.

Get the Most From This Exercise
You can follow these steps and copy my drawing of the three coins, but to learn the most from this exercise, place a coin on your drawing table and light it from the upper left. Light it from the right if you are left-handed. Move it around or prop it up until you see good contrast and reflections from the light. Use this as your model for the lettering details of the other coins.

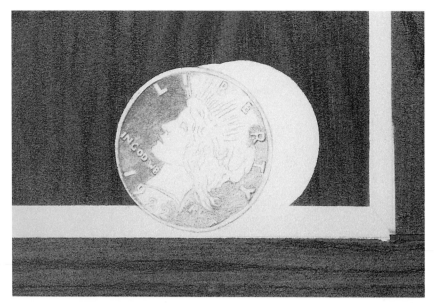

2 Add Value

Now the fun begins. Look closely at the subtle value changes on your model coins or my finished drawing. Start shading the dark areas of the coins lightly with a rounded 2H graphite pencil. On the left side of the areas that appear raised, such as the face and the letters, make a seamless transition between the outline and the area you are shading. Overlapping, circular strokes work best to avoid directional lines. Use an F graphite pencil to add the cast shadows on the lower right of the raised portions.

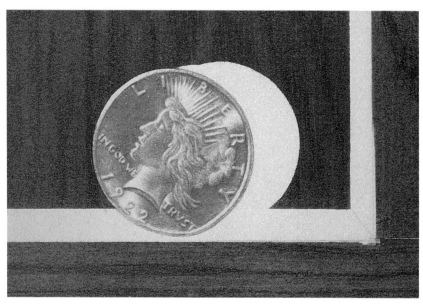

3 Refine the Values

As the drawing becomes more detailed, you need to use both harder and softer pencils to create a wider range of values. For the first coin I used a 6H for lightest areas next to the highlights and a 6B graphite for the shadows created by the raised areas.

These three coins are part of a still life on page 8. I set up the arrangement in my studio and lit it from the upper left side to get the placement of all the elements and their cast shadows. I laid a coin in front of me on my drawing table to see the details more clearly. Since my drawing light is also on the upper left, I could place pieces of a kneaded eraser under the coin and adjust it to recreate the lighting of the coins in the still-life arrangement.

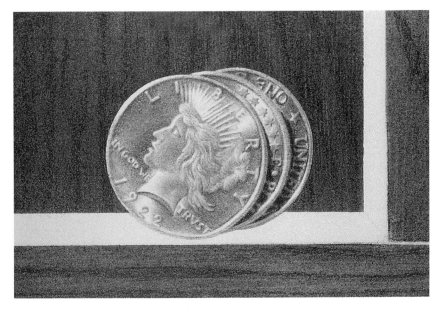

4 Develop the Other Coins

Render the details and values on the other coins the same way. Compare the other coins to the first one, and adjust the values with your kneaded eraser and the appropriate pencil. The third coin is darker because it is standing straight up, while the others are angled toward the light source. I used a 3B graphite pencil for the dark value of the third coin and a 6B for the cast shadows from the other coins.

This shadow is part of the total composition on page 8. It was placed here in the composition to add contrast to the coins.

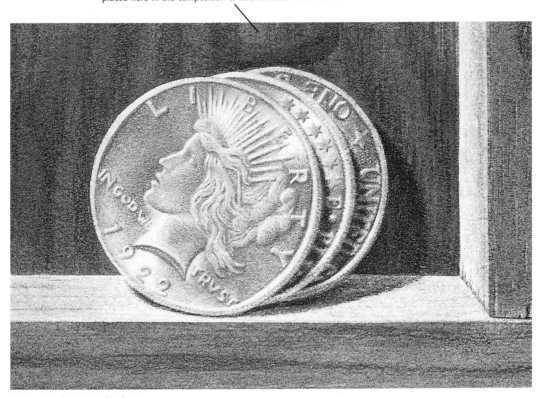

5 Place the Cast Shadow

Using charcoal for the cast shadow will add a reflective quality to the coins. Use a 3B charcoal pencil for the shadow on the back wall and HB charcoal for the shadow cast on the ledge. Keep your pencils sharp to get a clean, crisp edge where the shadow touches the coins. Once the cast shadow is in, you may want to lighten or darken some places on the coins. Remember to cover the area to keep from smudging the shadow into the coins.

People

Many years ago, I read that each human being is in fact *three* people: the way we view ourselves, the way others view us and the way we actually are. I believe this holds true for physical appearances also. Usually the portrait artist must choose between his view of the subject and how the subject views himself. Although they would not admit it, many clients truly want a portrait of how they *wish* they looked. I have smoothed wrinkles, slimmed waists and straightened both noses and teeth to please portrait clients. Another thing that goes a long way toward pleasing portrait clients is the ability to *effectively* reproduce the textures of the human head. Eyes, skin and hair all have distinctively different textures. You can imitate these textures more realistically with graphite, charcoal and various blenders than with a single medium or technique.

Eyes

Distinguishing Characteristics

Shading on the Eyeball Remember that light strikes the eyeball just as it does the rest of the face. That means the entire eyeball has light and shadow. The highlight frequently covers part of the pupil in the eye, which is drawn with dark charcoal. To keep the highlight white, mask it with liquid or frisket film. Removing this frisket and cleaning up the highlight is the last step in drawing a portrait. Many artists resist applying tone to the white of the eye, but the corners of the eyeball receive less light and must be shaded darker than the rest of the eyeball. Use graphite and blend with a chamois to achieve the smoothest shading possible.

Wetness of the Eye Along with the highlight on the pupil and iris, smaller highlights, particularly in the corners of the eyeball, give a look of wetness to the eye. They stand out because of the darker shading in the corner of the eye. If the portrait is large enough, use frisket for these small highlights. For smaller portraits use the indenting technique or carefully scrape out the highlights with a razor blade after the eye has been fully rendered.

The Baby

Darken crease above the eyelids with HB charcoal

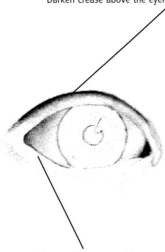

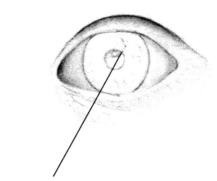

Thickness of bottom eyelid

Mask highlights with frisket

1 Outline the Eye Shapes

Lightly outline the eye shape with an F graphite pencil. Keep in mind that the eyelids wrap around the eyeball and conform to its shape. Think of the iris as a disk sitting on the eyeball. Remember to include the thickness of the bottom eyelid, which is almost always visible. When you are pleased with the shape of both eyes, cover the highlights in each eye with frisket. Use an HB charcoal pencil to darken the crease above the eyelids. Then, shade the eyeball with an F graphite pencil and blend with a chamois.

Initial strokes of F and 9B graphite before layering and blending

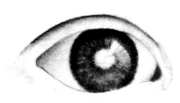

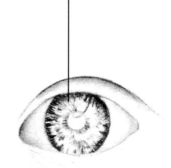

2 Add the Iris

Add tone to the iris by using a sharp F graphite pencil followed by a 9B graphite to add lines that radiate outward from the pupil. Leave some spaces between the lines. Blend the lines with a tortillon and repeat the process.

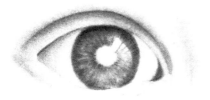

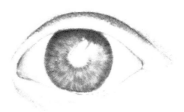

3 Refine the Values

Add more HB charcoal to the crease above the eye and blend down toward the eyeball with a tortillon. Blend the iris on the right. Then, use a kneaded eraser to pick out some white strokes on each iris.

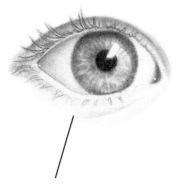

To keep the eyelashes from smudging, develop the shading around the eyes first.

4 Add Lashes, Pupil and Shading Around Eyes

Lightly sketch in the eyebrows with a sharp B graphite pencil. Then, use layers of F and 2B graphite blended with a chamois to render the shading around the eyes. Originate the strokes and the blending at the crease of the eyelids and extend to the eyebrows and edge of the nose. After developing these areas, you can add eyelashes with a very sharp HB charcoal pencil. Pick out the highlights in the corner of each eye with a razor blade, and clean them up with the sharp point of your kneaded eraser. Finally, use a sharp 3B charcoal pencil to darken the pupil. Leave the frisket in place to protect the charcoal while the rest of the face is rendered.

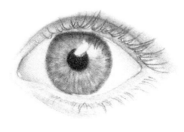

Size Dictates Medium

Sometimes the size of the drawing determines which medium works best in a particular place. If you feel HB charcoal is incapable of making a line thin enough to represent the eyelashes, try using a soft carbon or graphite pencil sharpened to a fine point. By the same token, if your drawing is larger, mask the small highlights in the corners of the eyes instead of scraping with a razor blade to make them white.

Hair

Since graphite is used for the texture of skin, using charcoal to render hair naturally produces a contrasting texture. The reflective graphite on the face seems to glow and come to life when adjacent to hair rendered in charcoal. Finish the face before you add hair. Consider how the hair color relates to the skin tones on your drawing. Decide if the base value is lighter or darker than the base value of the skin tones. Look for the shapes of the light and dark areas in the hair, then make your strokes in the direction of the hair.

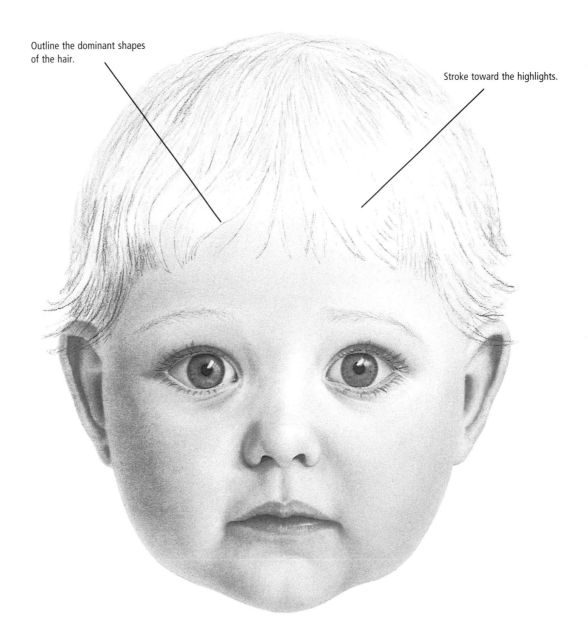

Outline the dominant shapes of the hair.

Stroke toward the highlights.

8 Begin the Hair
Start with an F graphite pencil and lightly outline the basic shapes of the hair, including the areas of the shadow and highlight. Then, with an HB charcoal pencil apply strokes in the direction of the hair. Start in the dark sections and stroke toward the highlights. For long strands of hair, use the overhand or underhand method of holding the pencil to ensure fluid lines.

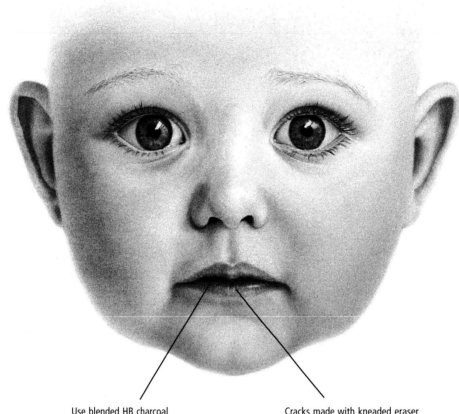

Use blended HB charcoal
as shadow on lower lip.

Cracks made with kneaded eraser

7 Check Values and Darken Lips

Continue to compare values and make adjustments. Add more media where necessary, and use your clean chamois and kneaded eraser to lighten areas. Then, lightly blend the strokes on the lips with a tortillon. It doesn't hurt to have some visible strokes here to produce a slightly rougher texture than on the face. Darken the line separating the lips with an HB charcoal pencil, and blend down with a tortillon to form the shadow on the lower lip. With the same tortillon, darken the shadows in the corners of the mouth. Finally, use a kneaded eraser to add the highlights of cracks on the lower lip.

Imagine Stroking the Contours
This mental exercise will help you decide the direction of the value strokes used to shade the baby's head. Imagine you are stroking the baby's face with your finger. Take the route that most describes the forms. Your contour lines should follow the same path that your finger would take.

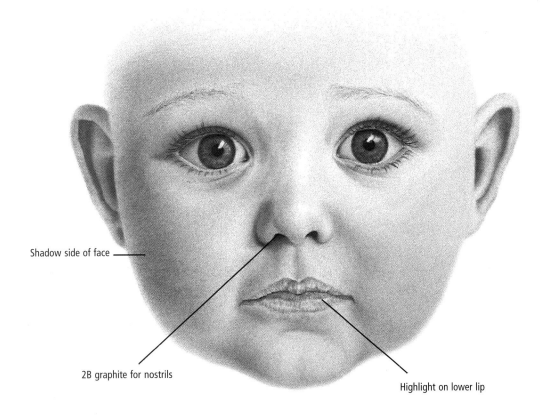

Shadow side of face

2B graphite for nostrils

Highlight on lower lip

6 Darken the Values and Blend
Continue to darken the large value areas of the head with 3B and F graphite pencils. Blend with felt and a chamois to smooth out the strokes. Render the ears and nose with 3B and F graphite. Smooth these strokes with a tortillon. When you are satisfied with the lighter values of the nose, darken the inside of the nostrils with 2B charcoal. The ear on the left should be darker because it is on the shadow side of the baby's head. Follow the forms of the lips, using short strokes with 6H and F graphite pencils. Leave a thin line of white on the lower lip for a highlight.

Skin

Although skin varies drastically from one person to the next, it all has one thing in common—because it wraps around the structure of the skull, it is subjected to the effects of light and shadow. Use lighting that exaggerates the skin texture of your subject. Light raking across the head at an extreme angle magnifies the irregularities in the skin texture, such as wrinkles and pits. This type of lighting is good for creating a character study featuring the rough texture of an older person's skin.

Three-quarter lighting is a good choice for most subjects. It's easy to see the forms of the facial features without accentuating skin irregularities. The light source is placed above and to one side of the head.

For reproducing the texture of a baby's skin, use lighting that makes it appear smooth. Bring the light around in front slightly more than the three-quarter lighting. Do not place the light directly in front of your model's face. It causes a flattening of the features, which makes it difficult to render them with a three-dimensional look.

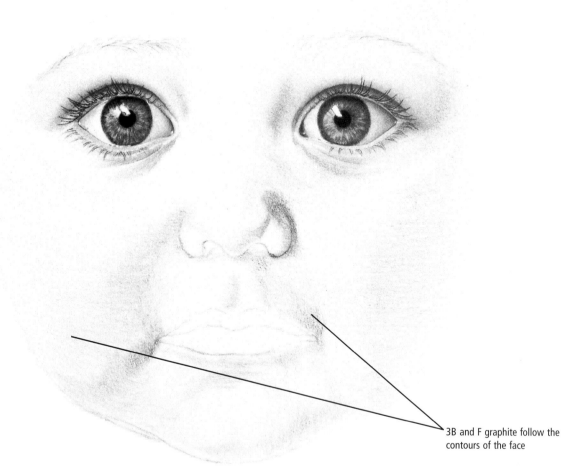

3B and F graphite follow the contours of the face

5 Begin the Skin

After blocking in the placement of the other facial features, use the underhand method of holding your pencil to add roundness to the face. Using short strokes, begin on the left side of the face with 3B graphite. Then, layer with F graphite using longer strokes that circle around to face the light. Repeat this on the right side of the face beginning at the edge of the cheek. Use the same approach for all areas with darker tones that gradually turn to face the light. Make sure your strokes follow the contours of the forms.

Use a Light Touch
Do not make a dark outline of the facial features. The nose and mouth must look like they are a part of the face rather than *attached* to it with a bad seam.

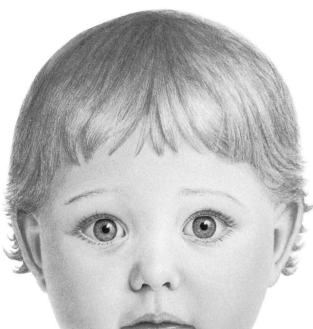

9 Finish—Darken and Refine Details

Darken with HB charcoal and blend with a stump. Use an H graphite pencil for the lightest strands in the band of light. Then, pick out the highlights with your Clic eraser pen. Next, apply HB charcoal with a tortillon to draw cast shadows of some hair on to the baby's forehead. Finally, remove the frisket from the eye highlights and refine their shape using the surrounding medium.

Another Portrait Example

This portrait illustrates the use of three-quarter lighting. It accentuates the rougher skin texture of adults and produces harsher shadows. To produce the skin textures, I rendered the shadow side of the portrait with charcoal that was gradually blended into the lighter values, which were rendered in graphite. A contrast of textures was created by using charcoal for the shirt and graphite for the neck.

Glass

Several qualities unique to glass are worth noting. Learn to recognize and imitate them, and viewers will easily identify the texture of glass in your drawings.

Distinguishing Characteristics

Smooth Texture The surface of glass is smooth, so use techniques that produce a smooth texture on your paper. Start with a smooth paper. The back side of Arches 140-lb. (300gsm) watercolor paper is a good choice if the drawing is not too large. If other parts of the drawing have elements that require you to use a rougher paper, flatten the tooth of the paper where the glass will be drawn.

For the lightest areas of glass apply hard pencils lightly and blend away the pencil strokes, or use soft blenders or brushes to apply the media directly.

Strong Highlights Highlights are essential for drawing realistic glass. Because we think of glass as clear, sometimes people have a tendency to use only light values. To render it more true to life, glass must have a wide range of values to make the highlights stand out. Try using a darker background, or place a dark object or shadow behind the glass object to increase the contrast between the highlights and the rest of the glass. If your subject can't be moved, position yourself or the light source until you see highlights on the glass. Bright highlights give your drawings of glass the characteristic sparkle that helps identify the subject.

Distortions Objects viewed through glass usually appear distorted. The amount of distortion depends on how concave or convex the glass is. Flat glass, such as a picture or window glass, also distorts—especially if it is viewed from an angle. By simply drawing the shapes you see you can render convincing distortions. Smooth blending is required, so a soft blender like a tortillon works best. Objects viewed through glass should be drawn with less contrast and clarity than the actual object. By including a piece of the object that is *undistorted* by glass, you can draw attention to this distinctive trait of distorted glass.

Reflections Just as with shiny metal, reflections of surrounding objects can sometimes be seen in glass. Look closely at everything that is reflected in the glass, and remove anything in your studio that causes a distracting reflection. Identify reflections of the objects that will be depicted in the drawing, and render them softly so they appear to be *on* the glass.

Media to Use Graphite has reflecting qualities that make it ideal for drawing glass. Charcoal or carbon may be used for the darkest values, but adding a layer of graphite on top adds a look of luminosity to glass. When adjacent to a darker background, shadow or other objects drawn with charcoal, the graphite on the glass appears to reflect light and pop forward in the picture. For a warmer look—for instance, glass in the sunlight—use Conté carbon followed by layers of graphite.

Mason Jar and Brushes

This drawing contains many of the characteristics of glass mentioned previously, plus the added elements of water and raised glass lettering. Don't let this intimidate you. If you start with a symmetrical shape and carefully map out the placement of the major value changes, everything will fall into place. The first step shows my initial outline of the value changes, but to do yours, you may find it easier to look at step 2, where the shapes are more clearly defined.

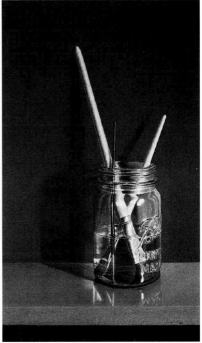

Finished Drawing

1 **Mask the Silhouette**
Begin by masking the silhouette of the glass, brushes and shelf top with frisket. Next, use several layers of 2B charcoal to fill in the background to a medium dark value. Blend with felt between the layers. Then, spray with fixative, remove the mask and lightly map the outline of the forms with an F graphite pencil.

2 Mask Highlights, Add Values and Distortions

First, place liquid frisket on highlights to keep them white. Start in the upper left of the glass, rendering the darkest values of the jar threads and the left side of the glass with a sharp B charcoal pencil. After establishing these dark values, begin rendering the glass over to the edge of the brush handle and down to the water. Render the shapes with B graphite over B charcoal for the dark values and B graphite alone for the lighter areas. Use circular strokes and blend the subtle shading with a tortillon for a smooth texture.

Next, render the shapes in the water surface with HB charcoal and F graphite. For the dark values below the surface, use both B and 2B charcoal followed with B graphite. Apply F graphite for the light area below the surface. Then, smooth all the media with a tortillon.

For the shadows on the tall paintbrush handle, lightly apply 2B charcoal and blend with felt. Where you see the handle through the glass, lightly apply the charcoal with a tortillon. Render the black paintbrush with a Wolff's B carbon pencil, leaving a highlight down the length of the handle. Use a sharp Wolff's B carbon pencil for the brush bristles also. To render the metal on the brushes under water, use Wolff's B carbon followed by B graphite and blend with a tortillon.

Layer Lightly
In areas where graphite is layered over charcoal, apply the graphite lightly so more charcoal may be added later if darker values are needed.

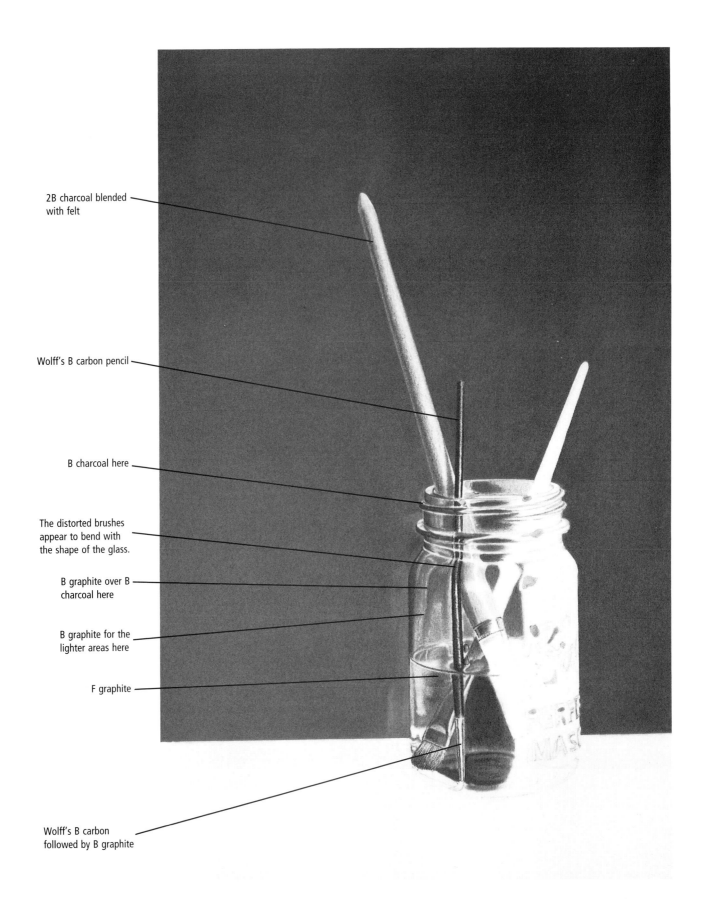

2B charcoal blended with felt

Wolff's B carbon pencil

B charcoal here

The distorted brushes appear to bend with the shape of the glass.

B graphite over B charcoal here

B graphite for the lighter areas here

F graphite

Wolff's B carbon followed by B graphite

3 The Light Side of the Jar

Remove the liquid frisket as you work your way across and down the jar. Use a sharp B charcoal with heavy pressure to render the jar threads. Apply HB charcoal lightly with a tortillon where you see the third brush through the threads. Leave the frisket in place while you render the lighter values on the right side of the glass with layers of B graphite over F graphite. Blend with a chamois after each layer. Remove the frisket and blend with a small tortillon next to the highlight. Next, apply and blend Wolff's B and HB carbon pencils to render the metal part of the long brush. Then, use layers of F graphite over B charcoal to apply the shading to the water up to the edge of the raised letters. When that's complete, begin developing the raised letters with 6H, H and 6B graphite.

Look Closely at the Shapes

Render distortions of the objects and reflections in the glass carefully. They help give the glass its form. The paintbrush handles appear to bend outward with the shape of the jar. Pay particular attention to where the long brush can be viewed through the surface of the water. This distortion is an important visual clue that helps identify the subject as liquid in clear glass. The ellipse that forms the surface of the water is critical. It gives depth and roundness to the jar. This ellipse must be drawn correctly to make the surface of the water appear level. The ellipse on the bottom of the jar is also critical for placing the jar solidly on the shelf.

Compare Values

The right side of the jar must be rendered fairly dark to allow the highlights and halftones on the raised letters to appear bright. To make the letters pop out more, you may need to darken the right side of the jar with more B charcoal and F graphite, as I did in step 4. Since all the values are related, the values on the left side of the glass must also be darkened to keep it darker than the right.

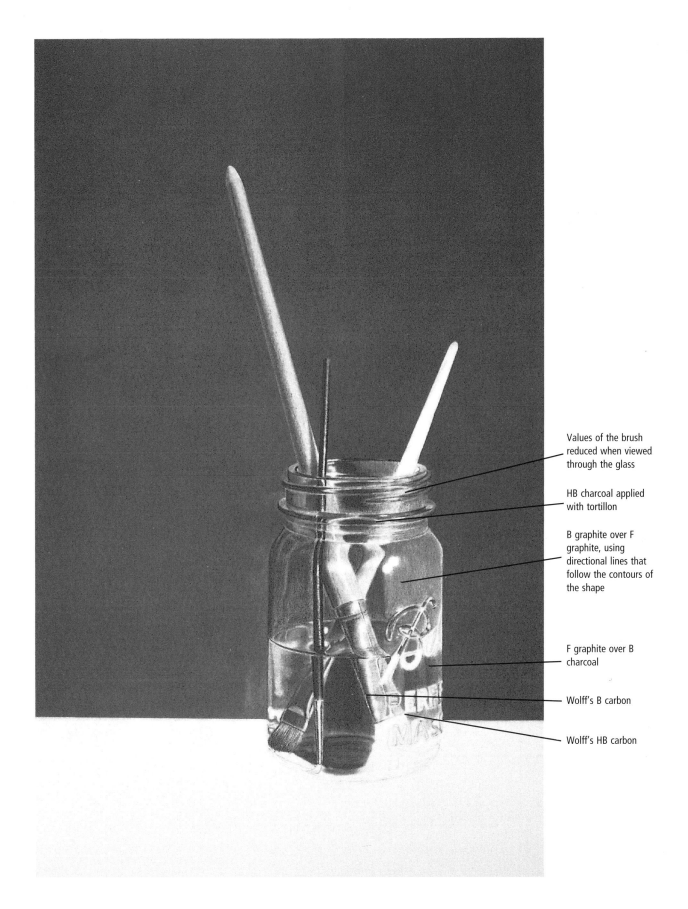

Values of the brush
reduced when viewed
through the glass

HB charcoal applied
with tortillon

B graphite over F
graphite, using
directional lines that
follow the contours of
the shape

F graphite over B
charcoal

Wolff's B carbon

Wolff's HB carbon

4 Define Values and Add Details

Apply 2B charcoal to the handle of the third paintbrush and blend with felt. Where the handle is diffused behind the glass, apply the charcoal with a tortillon. Add the vertical patterns on the right side of the glass with a 2B graphite pencil, and lighten the reflections with a kneaded eraser. Next, check your values on both sides of the jar, and make sure the left side is darker. Then, render the darkest values on the raised letters with 6B graphite. Use a 6H graphite pencil for the lightest halftones and an H graphite for the medium halftones. Leave the highlights white. The three values surrounding the white must be rendered cleanly. Use directional strokes that follow the planes of the letters to help define their form.

Adding Water Changes Everything
An ellipse delineating the surface of the water cuts through the letters of the word *Ball*. The letters reflect light differently when there is water behind them, so pay particular attention to the values and to the patterns that form the water's edge.

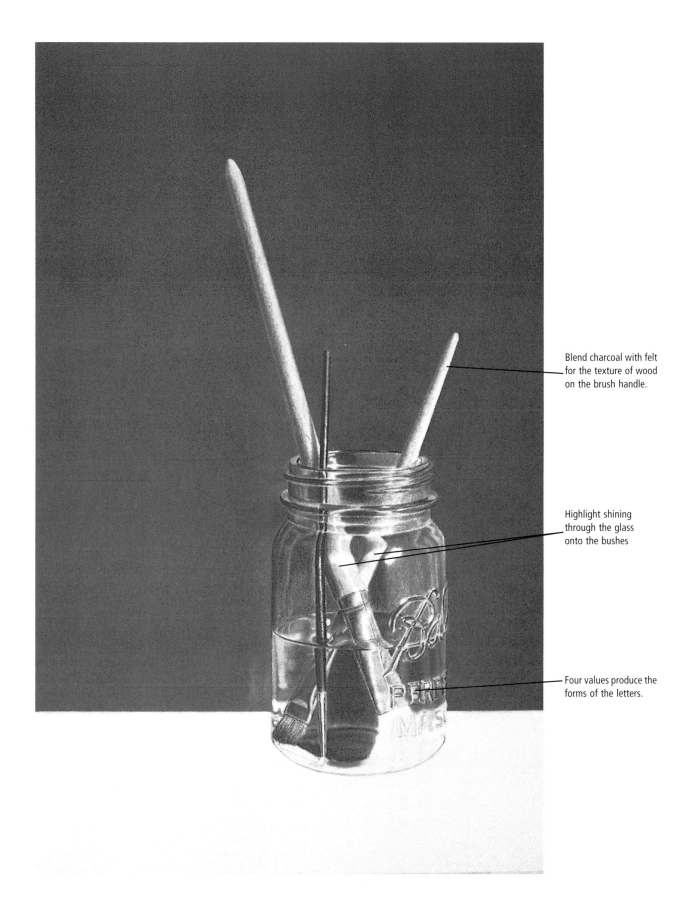

Blend charcoal with felt
for the texture of wood
on the brush handle.

Highlight shining
through the glass
onto the bushes

Four values produce the
forms of the letters.

5 Complete the Jar and Shelf

Use a Wolff's B carbon pencil to render the bristles on the large brush. Carefully work around the bright highlight and next to the letter *M*. Then, render the rest of the water followed by the raised letters, as you did in step 4. Use the B charcoal and F graphite pencils with more pressure for the dark values on the bottom of the jar.

Apply no. 3 vine charcoal with the broad side of the stick to begin the top of the shelf. Use horizontal strokes that emanate outward from the sides of the jar. Blend with a large soft tortillon using the same horizontal strokes. Repeat several times until you have achieved an even value across the top of the shelf. Next, use a paper towel to lighten this value to the right of the jar. Apply HB charcoal lightly with circular strokes, and blend with a tortillon to shade the reflection of the jar on the shelf. Use slightly more pressure to develop the darker areas of the reflected letters, and pull out the highlights with a kneaded eraser. For the cast shadow of the jar on the shelf, apply B charcoal pencil and blend with a tortillon. Where the shadow strikes the back wall, lightly outline the cast shadow shapes with 3B charcoal, and begin to fill them in.

Separate the top of the shelf from the front edge with a sharp line using an HB charcoal pencil. Then, layer and blend the entire front edge with a no. 3 vine charcoal stick and follow with an additional layer of 2B charcoal using horizontal strokes. Next, blend the front edge lightly with felt.

Set the Glass Down

Unless you want your jar to look like it's flying through the air, you'll need to draw something for it to sit on. I used layers of no. 3 vine charcoal to render a shelf. Introducing this medium here helps separate the shelf from the other tones and textures. Adding cast shadows will really help set the jar down solidly on the shelf. Before you add any charcoal for the shadows, turn your paper sideways to keep the dust from falling onto the jar.

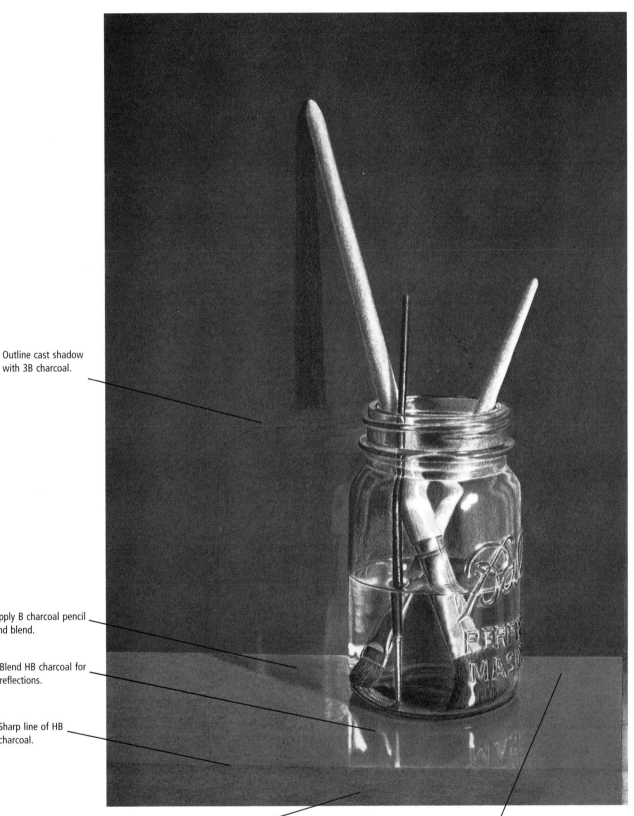

Outline cast shadow with 3B charcoal.

Apply B charcoal pencil and blend.

Blend HB charcoal for reflections.

Sharp line of HB charcoal.

No. 3 vine charcoal followed by 2B charcoal

Begin with horizontal strokes of no. 3 vine charcoal and blend.

6 Finish Cast Shadow and Fine-Tune Values

Fill in the rest of the cast shadow and blend lightly with a soft paintbrush. Render the shadow darker and more defined where the brush touches the wall. Use horizontal strokes with a clean piece of felt to lighten the value on the front edge and the right side of the shelf until its value is lighter than the left side of the shelf top. The charcoal you applied in step 5 will help retain texture on the front edge of the shelf to bring it forward in the picture. Use your kneaded eraser to pick out highlights for the texture. Then, layer and blend 2B and 3B charcoal to create the dark shadow under the shelf. Finally, clean up the highlights with a kneaded eraser, make any final adjustments to the values and spray with fixative.

Blending Tip

Blending materials and the way you use them can drastically change the look of your drawing. Certain types of felt, chamois and even paper towels remove more of the medium than others. Make sure you are getting the results you want before moving on. For instance, if using felt lightens the right side of the shelf top too much, reapply the vine charcoal and try blending it with a piece of paper towel.

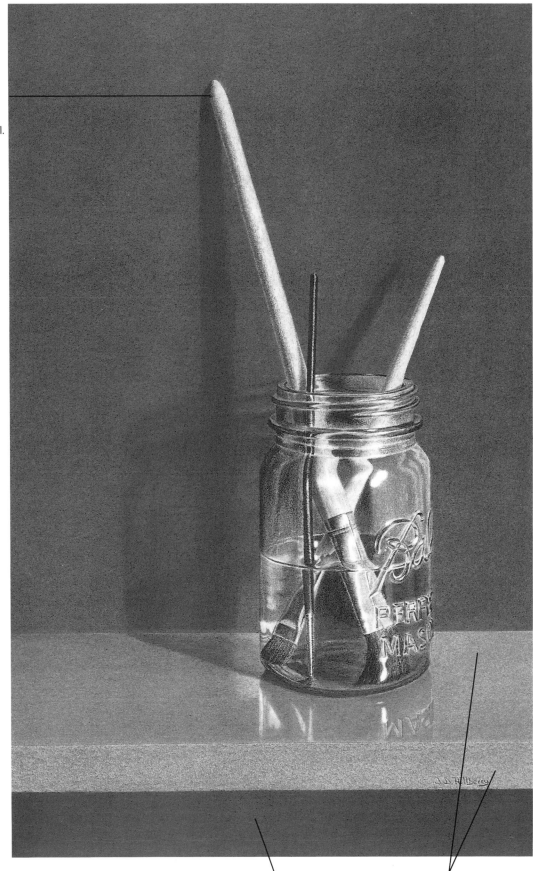

Cast shadow gets darker and more defined where the brush touches the wall.

MASON JAR AND
BRUSHES
Charcoal, carbon and
graphite pencil on
watercolor paper
17″ × 9½″
(42.5cm × 24cm)

Layer and blend 2B and 3B charcoal.

Lighten values with felt.

Broken Glass

Making glass appear to be broken may seem like a daunting task, but it is easily done if you keep in mind the things you have just learned about drawing glass. This is a drawing of Wild Bill Hickok behind what appears to be the broken glass in a picture frame. If you use the principles you know about rendering glass, you should be able to render any subject behind *broken* glass. All objects viewed through glass must be drawn with their range of values reduced. To show the same object in an area where a piece of glass is missing, a complete range of values should be used. An object behind glass—rendered with muted values and distortions—conveys the look of glass even more when it can also be viewed without the glass in the way.

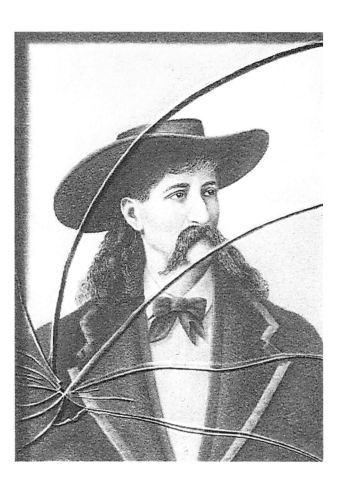

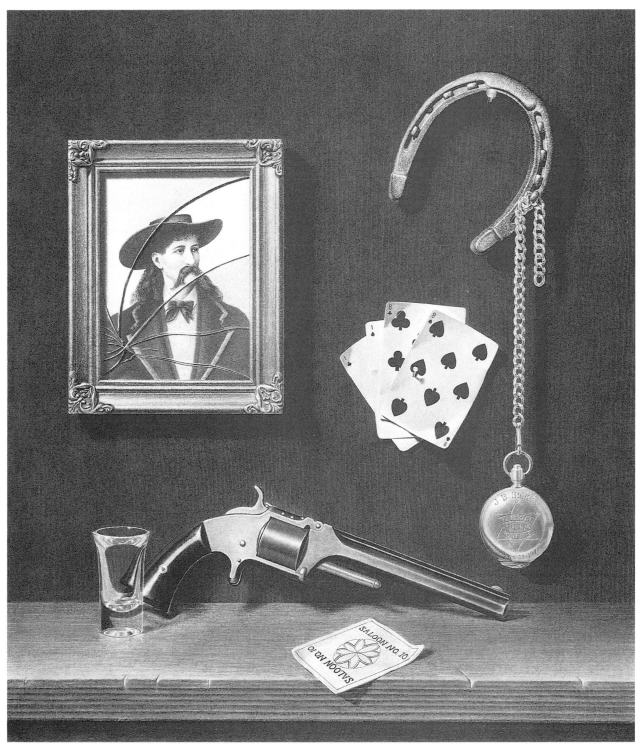

Burnishing the glass area flattens the tooth of the paper to give it a polished look. Everything that is viewed through the glass is layered with graphite. This mutes the values and gives the glass a smooth, shiny appearance.

ACES AND EIGHTS
Charcoal, graphite and ink on Crescent watercolor board
22″ × 19″ (55cm × 47.5cm)
Photo by Richard Stum

Weathered Wood

One of my favorite things to draw is wood with personality. The rugged surface texture of weathered wood can be rendered very realistically in drawings. It is an interesting subject by itself, or it can be used to add a contrasting texture when placed next to smoother objects in a drawing.

Distinguishing Characteristics

Rough Texture The obvious trait of weathered wood is its rough texture. If other elements in the drawing allow it, let the paper do some of the work by selecting one with more tooth that will add texture. Rendering wood usually requires a lot of reworking on the paper, so use a heavier weight. I like Crescent 100% rag cold-press illustration board. If you look closely at the tooth, you see a directional pattern. Turn the board to follow the general direction of the wood grain you are drawing. If you want to use a paper instead of expensive illustration board, try Strathmore 400 series regular drawing surface or Arches 140-lb. (300gsm) hot-press watercolor paper.

Wood Grain The appearance of wood grain varies depending on the type of wood and its condition. It's one of the first places where wood deteriorates, so in extremely weathered wood, the grain often turns to cracks. Some types of wood have a stronger grain pattern than others. No two pieces of wood are alike, but there are certain *rules* all wood grain must follow. Before you attempt to draw the wood I show here, find wood that contains a strong grain pattern and study it. Ask yourself these questions:

- Does one side of the grain have a sharper edge than the other side?

- Is the feathered edge of the grain always on the same side?

- Does one grain ever touch another?

- What happens to the grain when it approaches a knot?

When you understand wood grain and the basic patterns that are constant, you'll be able to draw wood textures without copying every grain you see on your model.

I like to think of wood grain as a little society. In the beginning, all the individual wood grains line up side by side and things are peaceful—if not downright dull. Then, one courageous grain decides to break the rules and make a little trip to the *left* but quickly gets back in line. A grain next to him sees that this explorer is unharmed by his adventure and perhaps has even gained something from the experience. He summons the courage to make the same trip. By venturing out farther than the first, he gains even more individuality. Several more follow, each one returning to the path looking less and less like the original society. Finally, one grain goes *so* far out he turns completely around and begins going in the opposite direction. He becomes the leader of a new society of opposite-going grains, which must conform to *his* wishes—until one of his disciples ventures out.

Roughing It Up Include surface irregularities like knots, cracks, holes, chips and splinters to bring character to your weathered wood. Render the main value of the wood and develop the wood grain before you add these irregularities. These irregularities are the icing on the cake, but you can only render them convincingly if you have a cake to put them on. If you invent your own wood texture, these extras can be strategically placed to balance a composition or to lead the viewer's eye to a point of interest.

Knots No two knots are alike, but I have observed similarities that can help you understand how to draw them. They come in a variety of sizes but are usually the largest naturally formed irregularities found in wood. Knots deteriorate quicker than the rest of the wood and are often seen with cracks running through the middle. Think of a knot as a ring of wood grain wrapped tightly in a circle. The grain pattern gradually loosens up around the perimeter of the knot, where it's usually slightly darker than the wood grain. Toward the center, there is sometimes a darker circular pattern. This is usually where cracks in the knot originate. Knots are easily knocked out of weathered wood, leaving knotholes.

Cracks and Pits The key for rendering cracks and pits is paying attention to the direction of the light. Side or raking light works best. To imitate the look of a crack or hole you need three values. The darkest value is the line that represents the absence of light inside the crack. The lightest value, next to this line, depicts the edge of the wood that is facing the light. The middle value is the base value of the rest of the wood.

Slivers Slivers stick out away from the surface of the wood. Consequently, when light strikes a sliver it produces a cast shadow. Without this shadow, the sliver appears to lie flat against the wood.

This drawing was created from my imagination. If you use your own wood for this exercise, keep the perspective simple as it is here. Practice producing the wood textures on this flat plane before you attempt to render them in two- or three-point perspective. Keep the lighting simple. In this drawing, the light is coming from the upper left of the wood.

Nails If a nail is partially pounded into wood, it casts a shadow. The length and direction of the shadow are clues to the nail's angle and how far it protrudes.

The Medium Charcoal is the best medium for rough wood. When overlapping parallel strokes are blended evenly with felt, they remain visible. These pencil lines help depict the texture of the wood as you create its base value. By using harder or softer pencils, or by layering more, you can change this base value. Over it use short parallel strokes with more pressure for the look of wood grain. Darker *unblended* charcoal pencil strokes work well for the cracks and holes.

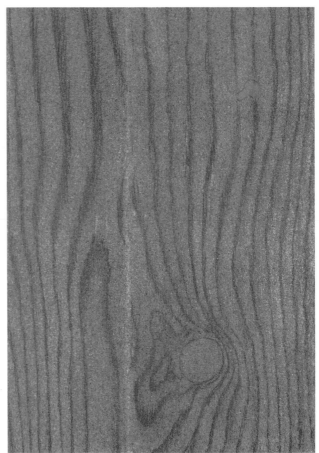

1 Mask the Nail and Develop the Base Value
Cut a nail silhouette from frisket and apply it to the upper right of your paper. To see the shape more clearly, look at step 8. Then, beginning in the upper left, apply 2B charcoal with short vertical strokes down the length of your paper. Use the technique described on page 26 for creating texture with no value changes. To make two boards, leave a narrow strip of white to separate them. Now, blend the entire area with felt using vertical strokes. Repeat this until you have an even value everywhere on your drawing. Blend over the white line also. It can be lightened later with an eraser.

2 Render the Grain
Use a B charcoal pencil to make short vertical strokes for the grain. Taper the lines by using more pressure at the beginning of the stroke than at the end. This produces both the hard edge of the grain and a soft feathered edge. Then, lightly blend the entire wood surface with felt. This makes the grain appear embedded in the wood rather than drawn on top of it. If too much of the wood grain disappears with the blending, repeat the process using more pressure with the charcoal pencil.

For Whiter Highlights, Use Liquid Frisket
If you want the base value of the wood to be lighter, you need to keep the highlight areas free from all media to make *them* lighter also. In this case, you could use frisket to mask the white strip that separates the two wood planks.

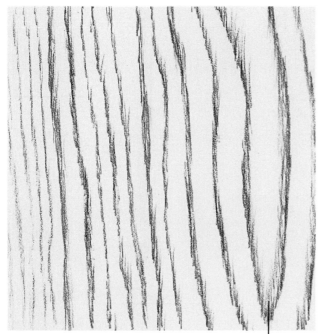

Typical Wood Grain Without the Underlying Wood Tone
You can see the wood grain marks more clearly here. Produce the feathering effect by making short, parallel strokes while decreasing the pressure applied to the charcoal pencil.

Use upward strokes to feather the wood grain.

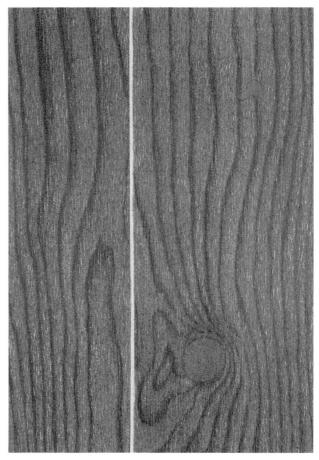

3 Add More Texture
Use the sharp edge of a Clic eraser pen to make short, thin lines of white over the base value wood. Cut back into the wood grain on the feathered side to accentuate the effect.

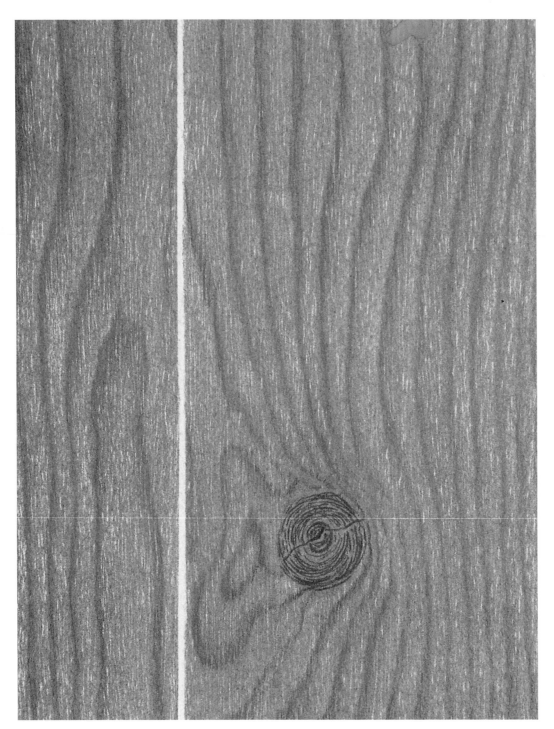

4 Draw the Knot

Draw a jagged line for a crack through the wood with a sharp 2B charcoal pencil. The general direction of the line should be perpendicular to the light source so the bottom edge of the crack faces the light source. Next, draw the outer circular patterns in the knot with a sharp B charcoal pencil. Use heavier pressure than you did while rendering the grain. Leave a space on the bottom of the crack line to lighten the edge. Render the darker areas toward the center of the knot with a sharp 2B charcoal pencil. Apply even more pressure on the pencil here, and blend the lines of the knot lightly with the felt.

No Haphazard Knots

If you invent your own wood texture, do not place knots haphazardly. The wood grain must lead into a knot.

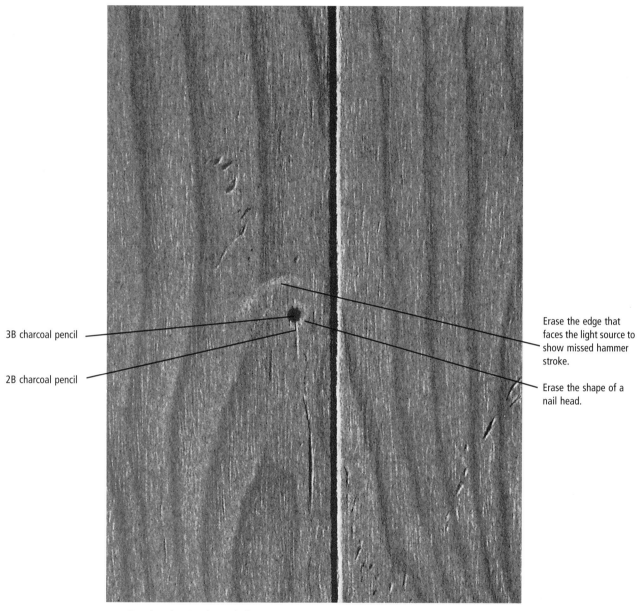

3B charcoal pencil

2B charcoal pencil

Erase the edge that faces the light source to show missed hammer stroke.

Erase the shape of a nail head.

5 Render the Cracks and Pits

Render the space between the two boards like a big crack. If you applied liquid frisket to keep the edge of the right board white, remove it. If you blended over this edge while rendering the wood, use your Clic eraser pen to lighten this line. Then, apply heavy pressure with a 3B charcoal pencil to produce the darkest value possible on the left side of the white line. Make a circular shape with 3B charcoal for a nail hole. Use your kneaded eraser to lightly erase some charcoal from around the perimeter of the hole to produce the shape and size of a nail head. Erase some charcoal in a larger quarter-circle shape above it. This will be the indentation of a missed hammer stroke. Next, use a sharp 2B charcoal pencil to add more dark lines and pits. Use your kneaded eraser to lighten the right and bottom edge of the wood texture next to the dark lines. Do this for the cracks in the knot also.

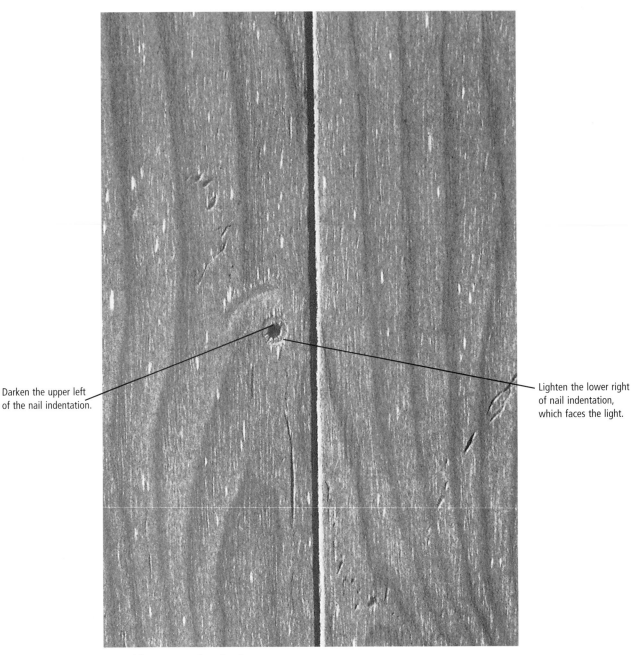

Darken the upper left of the nail indentation.

Lighten the lower right of nail indentation, which faces the light.

6 **Add More Detail to the Area**
Make the indentation of the nail head appear recessed by darkening the upper left of the circle with an HB charcoal pencil and blending. Then, lighten the lower right of the impression and the hole with a kneaded eraser. Use your Clic eraser pen to make more short, white marks around the drawing. These will become slivers and grooves.

Wayward Hammer Strokes
Missing a nail with a hammer is something I'm familiar with. It causes damage to even the finest wood—not to mention your thumb! When the head of the hammer strikes the wood, it usually creates a dent in the shape of a quarter moon. Depending on how hard you whack it, it may even create splinters around the indentation. Pounding in nails and removing them also causes splintering of the wood, which should be included to add more realism to your drawing.

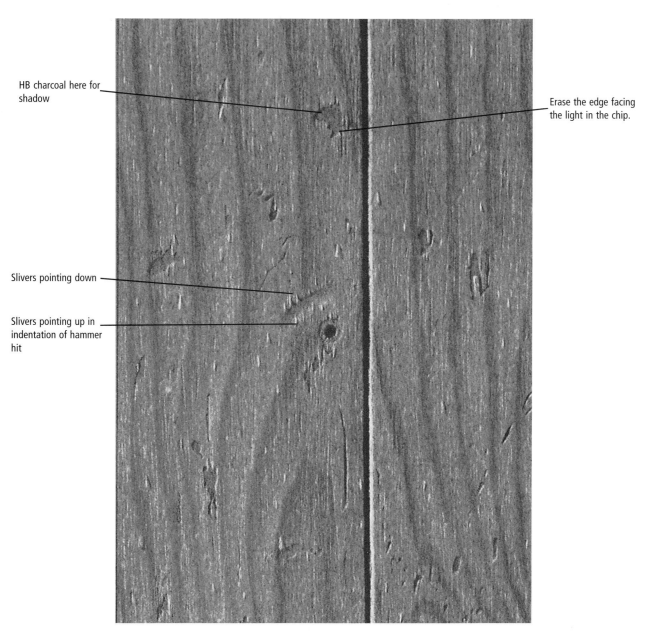

HB charcoal here for shadow

Erase the edge facing the light in the chip.

Slivers pointing down

Slivers pointing up in indentation of hammer hit

7 Add Shadows and Chipped Wood

Use an HB charcoal pencil to add shadows of the slivers on the right side of some of the white lines. To make a sliver that points down, start the charcoal line at the top of the white line and extend it down to the right, past the white line. To produce a sliver pointing up, start the charcoal line at the bottom of the sliver and draw the line up to the right. Do not extend the shadow line past the sliver. Imitate small grooves in the wood by placing the charcoal line on the left side of the white lines and blending lightly. Add chips or missing pieces of wood, by lightly applying HB charcoal in the shape of a chip. Next, in the upper left of the shape, use a sharp point on the HB charcoal pencil to indicate the shadow of the surrounding wood. Then, lighten the wood next to the lower right edge of the shape with a kneaded eraser.

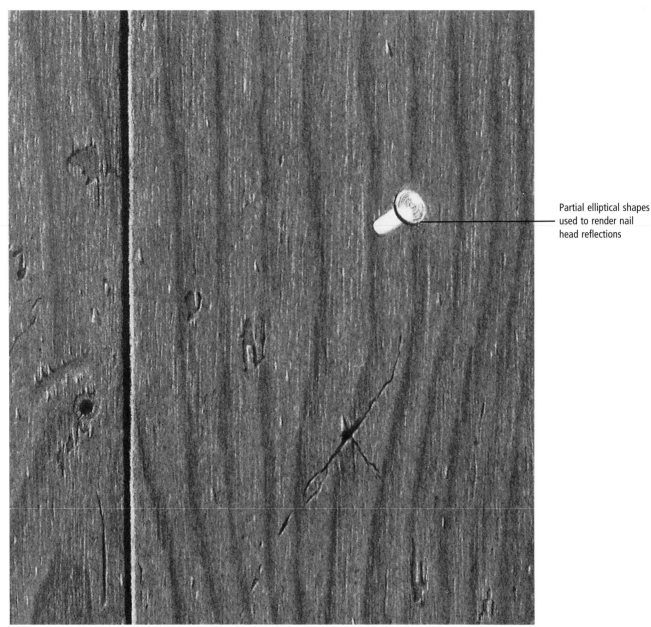

Partial elliptical shapes used to render nail head reflections

8 Begin the Nail

Remove the frisket covering the nail shape. Clean up any jagged edges of the shape with a sharp HB charcoal pencil and blend with a tortillon. Use a sharp Wolff's B carbon pencil to draw the partial ellipse that forms the edge of the nail head. Then, use a 2B graphite pencil to form the shapes of the reflection on the head of the nail. Follow the shape of the head using partial elliptical strokes.

A Protruding Nail

Draw a protruding nail at an angle so more of the shaft is visible. Seeing the shaft and extending the cast shadow makes the nail appear to protrude from the surface of the wood. From an angle, the edge of the nail head is visible and the head is seen as an ellipse. This nail is angled away from the light source, making darker reflections on the head and a brighter highlight on the nail shaft than if it was angled towards the light. It is also slightly larger than normal to illustrate the shading strokes that follow the contours of the shape.

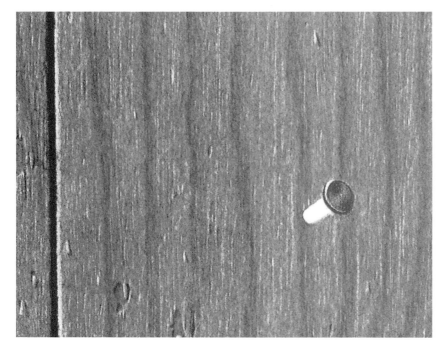

9 Darken the Nail Head

Continue to develop the nail head by applying an F graphite pencil to the lighter reflection shape. Then, layer the head with softer pencils for both areas on the head until you are using at least a 6B graphite pencil for the dark values and 2B for the lighter sections.

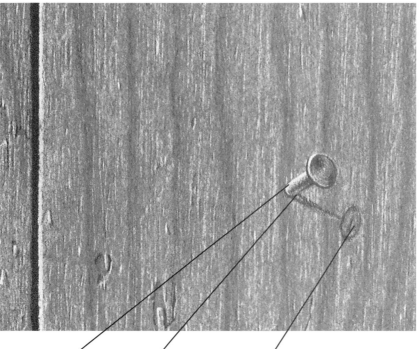

Highlight Reflected light on the bottom of nail shaft Extended cast shadow makes the nail appear to protrude.

10 Begin the Nail Shaft and Outline the Cast Shadow

Follow the contours of the nail shaft, with a sharp Wolff's carbon pencil. This will be darkest area of the shaft. Leave a place under the shaft for reflected light. Then, use an HB graphite pencil where the shaft begins to face the light more directly. Layer 3B graphite over the HB graphite and blend lightly with a tortillon. With the tortillon, add shading to the reflected light under the nail shaft. Keep the top of the shaft white for a highlight. Examine the values between the nail head and the shaft and make adjustments. I used a kneaded eraser to lighten the lightest reflections on the nail head. When you are pleased with the values, outline the cast shadow shape lightly with 2B charcoal.

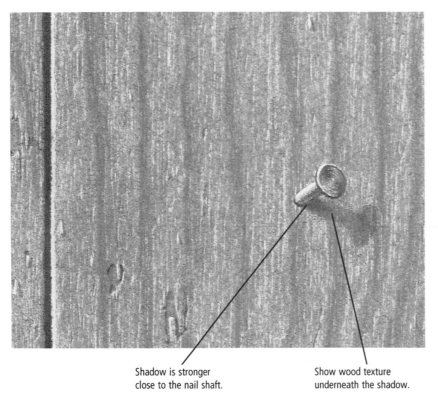

11 The Finished Nail

Fill in the cast shadow with 2B charcoal, using vertical strokes. Use more pressure close to the nail shaft, where the shadow would be stronger. Blend the shadow lightly with a small tortillon. Then, make several thin white lines through the shadow with your Clic eraser pen to represent the texture of the wood. Finally, use your darkest 3B charcoal pencil to make the edge of the hole caused by the nail.

Shadow is stronger
close to the nail shaft.

Show wood texture
underneath the shadow.

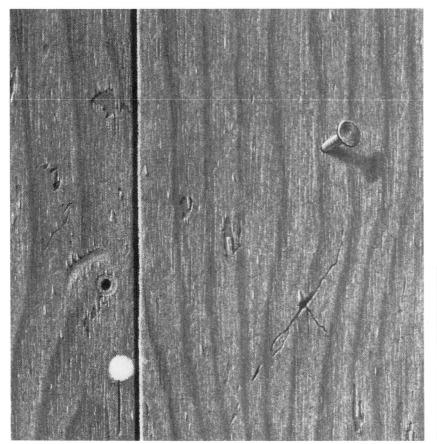

12 Add a Nail

Begin by erasing the circular shape of the nail head with your typewriter eraser. Pick up the eraser residue with your kneaded eraser. Then, replace the surrounding wood texture by reapplying HB charcoal and blending.

Observe the Direction of the Nail
This nail is pounded in all the way, and the nail head faces the light more directly. This causes the lighter reflections on the head to appear brighter. Use the same techniques to draw all nails regardless of the direction they face. Simply adjust your values for the direction the nail faces.

13 Render the Nail Head

Outline the nail head with a sharp F graphite pencil to give it a crisp edge. Then, use a 2B graphite pencil to apply strokes that follow the circular shape of the nail head. Leave a band of white across the center for the lighter reflection. Add a light halftone to the reflection by using circular strokes with a tortillon to blend the graphite *into* this strip of white. Leave the upper left of the nail head white to indicate a highlight. Use a sharp 2B charcoal pencil to add the shadow on the lower right.

Adding More

The great thing about working with this medium is it is so forgiving. As long as you haven't sprayed on fixative yet, you can always create new features for your wood. Here, I added another nail.

Leather

Distinguishing Characteristics

A strong contrast between the highlights and the base value is typical of leather. Cracks are usually visible even in new leather, which makes it a good subject for the indenting technique. Stitches are also common and the technique can be employed to render them as well. Charcoal is the best medium to use for dark cracked leather. Leather containing lighter values can be drawn realistically with graphite.

Leather Purse
This black purse may not be an exciting subject, but its high contrast and cracks make the texture of leather easy to identify. This step by step will teach you the fundamentals of drawing leather. Use these same basic techniques to render all the leather in your drawings.

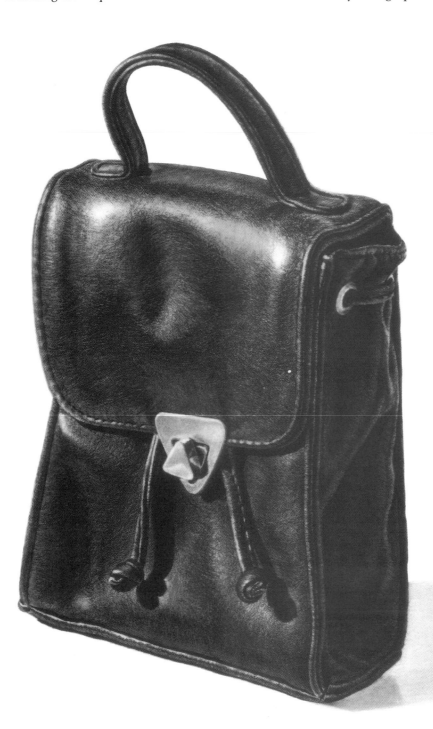

Leather Purse

1 Outline Shapes and Mask Metal
Lightly outline the subject and the major value changes with an F graphite pencil. Then, mask the metal latch and grommet with frisket film.

Impressions follow
contours of wrinkles

Stippling for
lighter halftones

2 Indent the Paper for the Cracks
Lay a piece of tracing paper over your outline. With a 6H graphite pencil, make grooves in the paper following the underlying forms. Make the most indentations in the wrinkles of the leather where the form curves from the shadows to the halftones. In addition to linear indentations, use stippling to create some small round impressions. Place most of these in the lighter halftone areas.

Examine the Cracks
If you look closely at the cracks in the leather, you'll see they are most apparent in the halftones next to the darker shadows. Step 2 shows the direction and type of impressions I made and how they relate to the underlying forms. Make indentations that follow the contours of the purse.

Keep Your Kneaded Eraser Handy
Dark drawings that contain large amounts of charcoal can be difficult to work with. Review the techniques in chapter two on keeping your drawings clean, and use your kneaded eraser to dab up any charcoal particles that stray onto the white of your paper.

3 Add Tone
Begin in the upper left using HB and 3B charcoal pencils to add tone to the front of the purse. Follow the contours of the forms with the 3B charcoal for the dark areas and the HB for the lighter sections.

To avoid smudging, develop the surrounding areas before adding cast shadows.

Use a hard HB charcoal pencil for dark, hard edges.

Make Adjustments in the Indentations
The indentations will appear when you begin to apply the tone. You can fine-tune or even eliminate some of them by filling in the impression with a sharp HB charcoal pencil and blending with a small stump.

4 Blend With a Tortillon
Refine the values by blending with a tortillon, adding more charcoal and repeating. Develop each section slowly before moving on. Use *less* blending in the areas where you want the *most* texture. Use 3B charcoal for the cast shadows, but do not add them until the surrounding values are done. Make sure the HB is sharp when you render the sharp edges, such as the handle and the seams around the edge of the purse. Produce all of the seams the same way. Start with the darkest part and make strokes that follow the contours around the form toward the highlight.

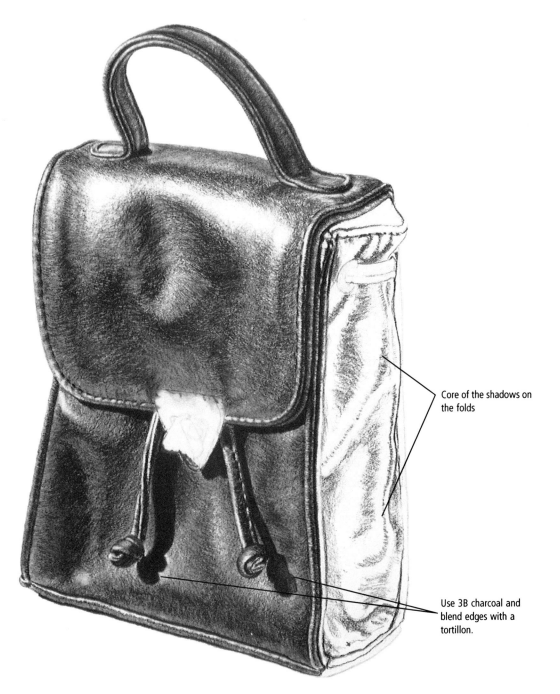

Core of the shadows on the folds

Use 3B charcoal and blend edges with a tortillon.

5 Finish the Front of the Purse

Continue to work from left to right, adding more tone and blending as you go. After the surrounding textures are complete, use HB and 2B charcoal pencils to render the leather ties. Then, blend toward the highlights with a tortillon. Next, add the cast shadows with a 3B charcoal pencil and lightly blend the edges with your tortillon. Map out the contours on the shadow side of the purse with HB charcoal pencil. Follow the contours of the folds, and look for the core of the shadow on each fold. The details on the right side of the purse are visible only because of reflected light. This means that fewer textures are visible and the values are muted. To create this effect in your drawing, simply blend with felt.

Vary the Hardness, Vary the Texture

When you look at values to decide what hardness of pencil to use, keep in mind the type of texture the pencil will produce. Sometimes you need a light value with a great deal of texture. In situations like that, it's easier to let the paper and a soft pencil do the work for you by simply using a light touch. In light areas requiring *less* texture, use harder pencils. To add to the illusion of distance, use less texture in the sections farthest away. I used a hard HB charcoal pencil on the top left of the purse.

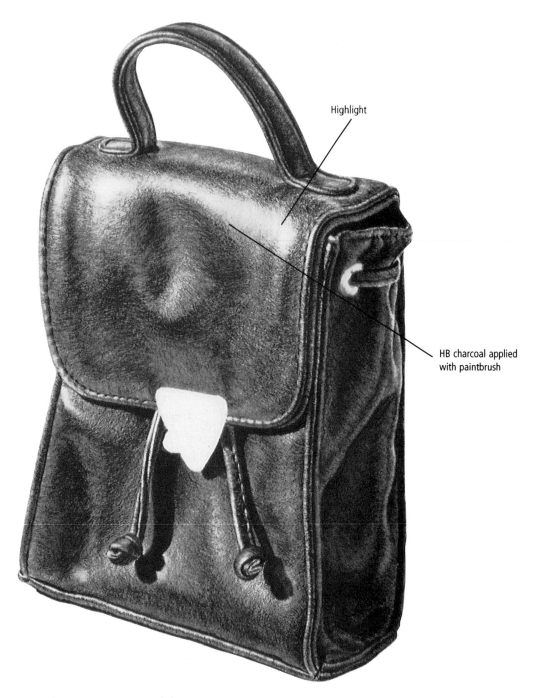

Highlight

HB charcoal applied
with paintbrush

6 Render the Shadow Side of the Purse

Follow the direction of the folds with B, 2B and 3B charcoal. Then, blend in the same direction with a tortillon. After the values are complete and the folds have shape, blend the entire side with felt. This helps minimize the detail and tone down the value changes. Finally, compare all the values and textures and make the necessary adjustments. To make the brightest highlights distinct, I darkened the light halftones next to them with a paintbrush loaded with HB charcoal.

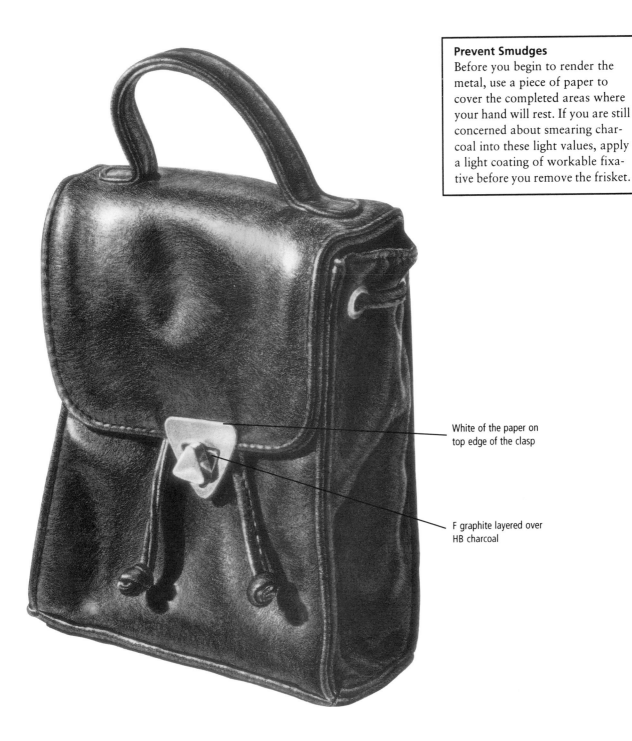

Prevent Smudges
Before you begin to render the metal, use a piece of paper to cover the completed areas where your hand will rest. If you are still concerned about smearing charcoal into these light values, apply a light coating of workable fixative before you remove the frisket.

White of the paper on top edge of the clasp

F graphite layered over HB charcoal

7 Remove the Mask and Render the Metal

Peel the frisket from the metal clasp first. Using circular strokes, render the halftones with a 6H graphite pencil. Leave a line of the white on the top edge of the clasp. Then, blend the halftones with a small stump. To add a shiny look to the metal, layer F graphite over HB charcoal and blend to render the darker sections of the latch. Finally, remove the frisket from the grommet and render it with 6H graphite.

Barbed Wire

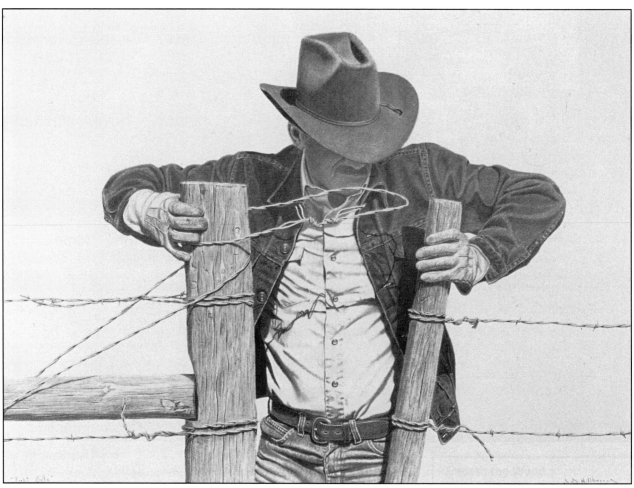

Although the barbed wire is a very small part of this overall drawing, it had to be rendered realistically for the drawing to be successful.

TIGHT GATE
Charcoal and graphite pencil on watercolor paper
20″ × 24″ (50cm × 60cm)
Collection of William and Tina Steinberg

1 Outline the Shapes

Use an F graphite pencil to outline the shape of the wire. No amount of shading will help if the overlapping wires are not drawn accurately, so take your time and make sure the twists make sense.

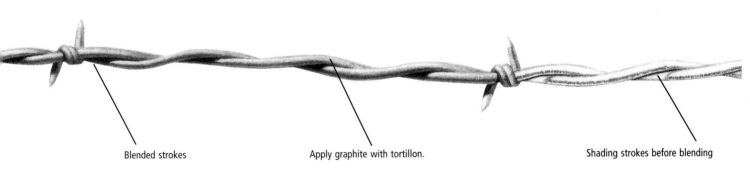

Blended strokes Apply graphite with tortillon. Shading strokes before blending

2 Add Tone and Blend

Use a 4B graphite pencil with upward strokes to add tone to the core of the shadow on the wires. Make sure you follow the contours when you add shading strokes to the barbs. Blend the wire and the barbs with a tortillon to smooth out the strokes and darken the bottom of the wire. Use the graphite on your tortillon to darken the top of each twist where it curves around. Then, use HB charcoal and blend with a tortillon to fill in the cast shadows. The right side of the wire shows the shading strokes used for the core of the shadow and the barb. The left side was finished by blending and adding the cast shadow.

Clothing

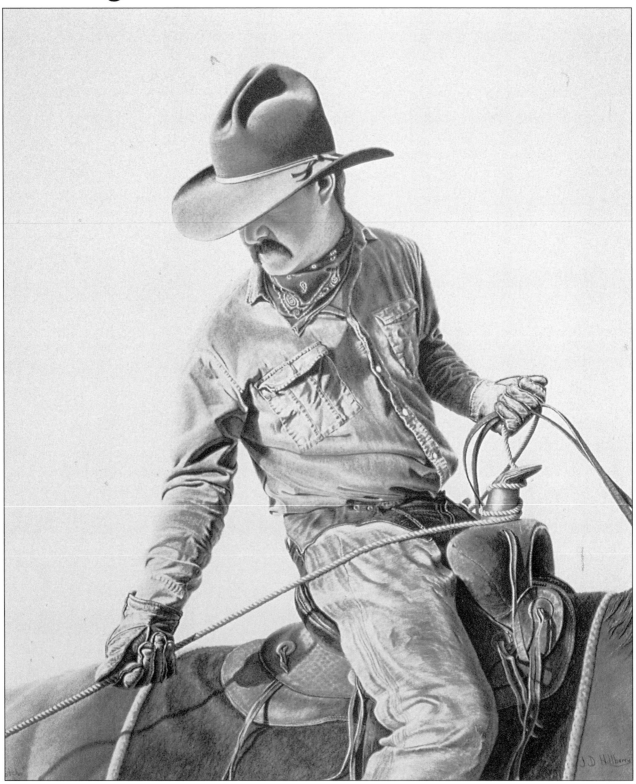

This drawing of my brother illustrates the folds and wrinkles that form on clothing when the subject is in action. The folds across the front of the shirt add to the feeling of twisting and reaching.

GOTCHA
Charcoal and graphite pencil on watercolor board, 22″×17″ (55cm×42.5cm)
Collection of Mr. Mike Boyer

Highlight—a true highlight exists only on the hat (not on the shirt) because the fabric there is too coarse.

Halftone

Core of the shadow

Reflected light

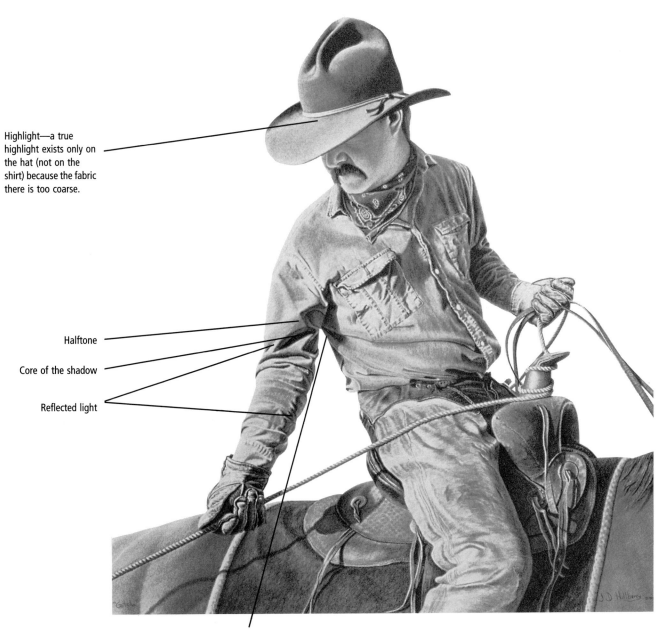

Cast shadow

Fur

At first glance, drawing fur looks intimidating. That's why the best approach is to simplify everything. To begin, map out only the major shapes of the fur. Simplify all the different values to light, medium and dark. Follow the direction the fur grows to tone the values. Use charcoal for the dark values and a stump or tortillon for the medium values. Leave the lightest areas white. Next, add overlapping strands of fur with an eraser pen and hard pencils. To make dark fur overlap light fur, simply draw the fur with an HB charcoal pencil or tortillon. To make light fur overlap darker fur, use the eraser pen to cut back into the dark values.

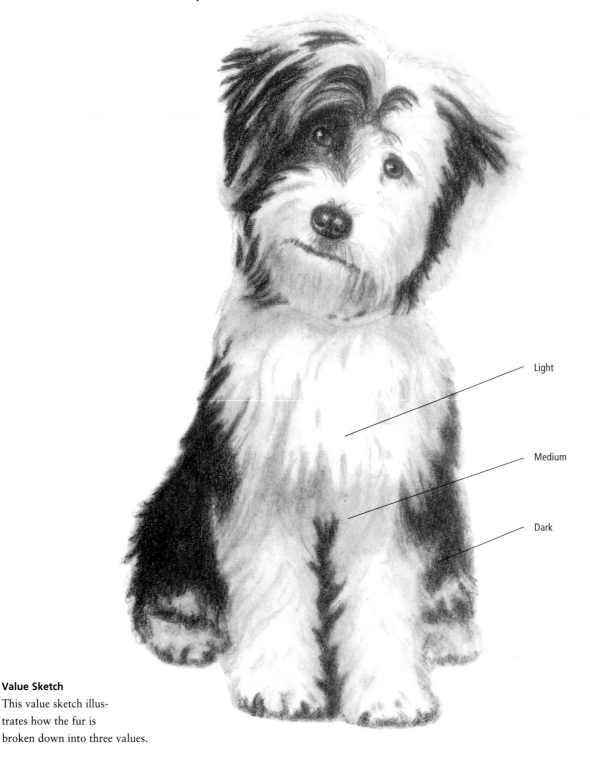

Light

Medium

Dark

Value Sketch
This value sketch illustrates how the fur is broken down into three values.

Use HB charcoal to make dark fur overlapping light fur.

Use Clic eraser pen to make light fur overlapping darker fur.

Create medium values with charcoal applied with a stump.

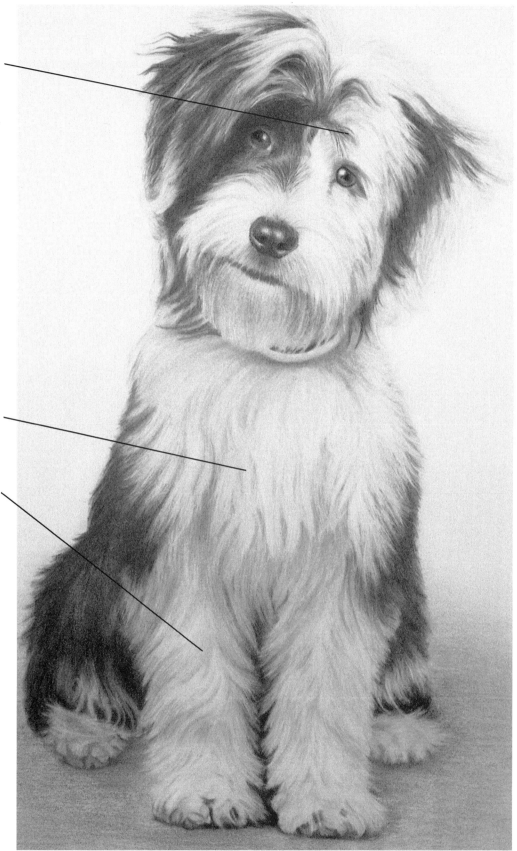

KIP
Charcoal and graphite pencil on Arches 140-lb.
watercolor paper, 20″ × 16″ (50cm × 40cm)
Collection of Jim and Jill Friederich

Put It All Together In a Still Life

An advantage of still-life drawing is being in complete control of the subject and the light. There is a reason for the placement of everything in a successful still life. Sometimes, moving an object a quarter of an inch or adjusting the light slightly on the setup is all that is needed to make the composition work. Each new arrangement presents a new problem to be solved.

While you are arranging the objects in your setup, you should experiment with the direction and intensity of the light. Raking side light accentuates textures the most, but it creates long cast shadows that may be hard to work with compositionally. Cast shadows are as important to a composition as the subjects. To give the shadows equal consideration, I find it useful to squint my eyes at the setup and think of all the values as abstract shapes on a flat plane.

Set up *visual clues* in your arrangements that add more dimension to your drawings. These are things like cast shadows falling onto more than one plane, the reflection of one object in another and reflections of shadows. When intentionally set up in your arrangement, they can enhance the sense of realism in your drawings.

PUTTING IT TOGETHER
Charcoal and graphite on Arches 140-lb. (300gsm) watercolor paper
16″ × 12″ (40cm × 30cm)
Photo by Richar Stum

Torn From the Sketchbook

The Idea

This complex drawing required careful planning. My idea was to draw some of my studio supplies and include a sketch of *the same drawing* in the still life. I spent hours arranging various studio materials on a shelf in front of my drawing board until I settled on these. I considered contrast, texture, repeated lines and negative space while searching for an interesting composition that would lead the viewer's eyes around the objects. I did several sketches before deciding the composition would be improved if the objects were drawn sitting on a cupboard with one door slightly open. This balanced the drawing by adding interest and contrast in the lower left corner. I don't have a cupboard like this, so I drew it using basic rules of perspective and my imagination.

The ruler is leaning against the wall. The *visual clue* that makes it appear this way is that the cast shadow gradually gets farther away from the ruler. This also helps create some depth on the cupboard top. Cast shadows that pass over more than one plane are particularly important in making objects look three-dimensional. For example, the shadow of the ruler conforms to the contours of the tape. Arranging it this way makes the roll of tape appear more real. The direction of the light and the angle of the nail holding the roll of tape were also arranged specifically to make the nail's cast shadow fall onto the roll of tape.

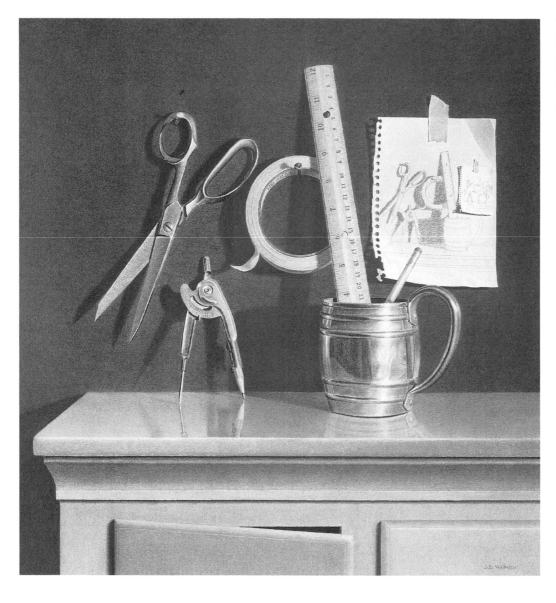

TORN FROM THE
SKETCHBOOK
Charcoal, carbon and
graphite on Crescent
watercolor board
20″ × 20″
(50cm × 50cm)
Photo by Richard Stum

1 Separate the Subjects From the Background

This drawing needs a dark background to make the objects pop forward. Begin by attaching frisket silhouettes of each object on Crescent rag board as explained on pages 41–43. Use drafting tape and paper to mask a straight line separating the back of the cupboard from the wall. Next, apply several layers of medium vine charcoal to the background, blending it with felt after each layer. Apply fixative to prevent smudging while rendering the objects. I am right-handed, so to keep smudging to a minimum, I always begin in the upper left. I remove the frisket from the scissors first.

2 Add the Values

For the shiny look of metal, use a Wolff's B carbon pencil for the darkest values. This brand of carbon produces a dark, rough texture that helps make the metal stand out from the background texture. Model the form with graphite pencils ranging from 2B to HB. The strokes follow the direction of the contours. Blend them with a tortillon in the same direction.

Choosing the Media for Metal

Metal looks convincing if it contains a value slightly darker than the background. In this drawing, a softer graphite pencil would have been too reflective against this dark background, and I saved the dark charcoal texture for the cast shadows. I chose a Wolff's B carbon pencil for the darkest values in the metal.

3 Refining the Details

For the details of the measuring marks and the numbers on the compass, use the indenting technique with a sharp pencil and tracing paper, as demonstrated on pages 38-39. Then, layer 2B graphite over the grooves, which remain crisp and white.

4 Cool and Rough vs. Soft and Warm

Render the rest of the compass with graphite and Wolff's B carbon, then switch to a Conté B carbon pencil applied with a soft tortillon for the pencil in the compass. The Conté brand has a softer texture and warmer tone than Wolff's does. This slight difference helps get the separation needed between objects that are close in value. Remove the mask covering the shape of the roll of tape, and apply Conté B carbon with a felt pad for the basic tone here.

Contrasting Textures

This area demonstrates the effectiveness of using media with contrasting textures next to each other. The texture of the unblended Wolff's B carbon pencil I used to render the nail helps separate it from softer tones of the roll of tape, which I applied softly with Conté carbon on a felt pad.

Conté B carbon here Wolff's B carbon here

5 Detail the Tape and Shade the Ruler

Use a Clic eraser pen to make circular white lines around the tape roll to suggest edges of the tape. Lightly add shadows to the left side of these lines with a Conté B carbon pencil and blend with a tortillon. Apply HB charcoal with a tortillon to make the shadows on the inside of the tape roll, then use a sharp Wolff's 2H carbon pencil to write the words "drafting tape." Switch to a Wolff's B carbon pencil to render the nail. For its shadow, I used B charcoal dabbed on with a small tortillon. Take the frisket off the ruler shape, and use long vertical strokes to lightly apply 2B charcoal with a felt pad.

6 Detail the Ruler

I moved the ruler from the set-up to my drawing table to get a better view of the numbers and measurement lines. Having the ruler this close helps in drawing the details, but remember to draw them in perspective so the numbers and measurement intervals gradually appear smaller as the ruler angles away from the picture plane. Use a sharp Wolff's 2H carbon pencil for these ruler details. To add contrast, lighten the roll of tape with the Clic eraser pen.

Render Tone Before Details
To avoid smearing small details like the printing on the ruler, always render the basic tone, texture and shading of the subject first.

Frisket for the cup is still attached to preserve a clean edge.

7 Render the Top of the Cupboard and Reflections

Block in a tone for the cupboard top that everything sits on. First, remove the drafting tape and paper masking the cupboard. The mask of the cup shape is still in place, so you can apply the medium freely and still retain a clean edge for the cup. Use horizontal strokes with an HB charcoal pencil, and blend with a chamois to smooth out the strokes. Repeat several times to darken it.

Lift the charcoal with a kneaded eraser in the area of the reflections and render them with the same medium as the real objects. In this photo, the compass reflection is complete and the charcoal for the cup reflection is being lifted.

8 Begin Rendering the Cup

Remove the frisket and lightly outline the changes in value on the outside of the cup with a Conté B carbon pencil. Then, use a Conté 3B carbon pencil to fill in the dark areas and a tortillon to blend toward the highlights. For the lighter areas, apply the carbon directly with the tortillon.

9 Finishing the Cup and Reflections

Complete the values on the outside of the cup. Then, load a tortillon with Conté carbon and add the details of the cup's reflection. All of the reflections will be softened and blurred later. Save the inside of the cup for later because it's difficult to keep its dark value from smudging into the ruler while working on other areas.

Reworking Large Areas

Going back to rework large areas of a drawing can be a little scary, especially if you have to avoid completed sections that can easily be smeared. If you are careful and take precautions to keep the drawing clean, it can be done.

10 Darkening the Background

Now you should have an idea of the basic values needed to give the objects a three-dimensional look. I decided to darken the background wall for more contrast. Cover the right side of the drawing with a clean sheet of newsprint, and begin in the upper left applying HB charcoal pencil to darken and smooth out the texture. To help balance the composition add more charcoal as you progress to the lower right of the drawing. This leaves the left side of the drawing slightly lighter in value, creating a spotlight effect. Lightly blend out the strokes with a sponge brush. To save the tooth of the paper, avoid darkening the large areas where the cast shadows strike the wall. This allows the paper to hold more of the 3B charcoal used there.

When you're satisfied with the background value, spray the area lightly with fixative and then peel off the frisket for the sketchbook page.

11 Establish Values for the Cupboard

Because of the spotlight effect, the left side of the cupboard top would also catch more light. So, lighten it by rubbing with a clean chamois. Lightening this side of the cupboard counterbalances the light value of the sketchbook paper.

Next, draw the placement of the cupboard doors and other major details of the structure with HB charcoal. Use a 2B charcoal pencil for the shadow directly under the cupboard top. Soften the bottom part of the shadow by blending it with a tortillon. Under that shadow, model and blend the larger shadow from dark to light with 2B and B charcoal. Continue to work down and across the cupboard, lightly applying B charcoal with vertical strokes to mimic wood grain.

Check the Values
After completing a large section or object in a drawing, step back and look at how it affects the values of the entire composition. In step 11, I lightened the left of the cupboard top to make it correspond with the spotlight effect I had created for the back wall. This also helped balance the composition.

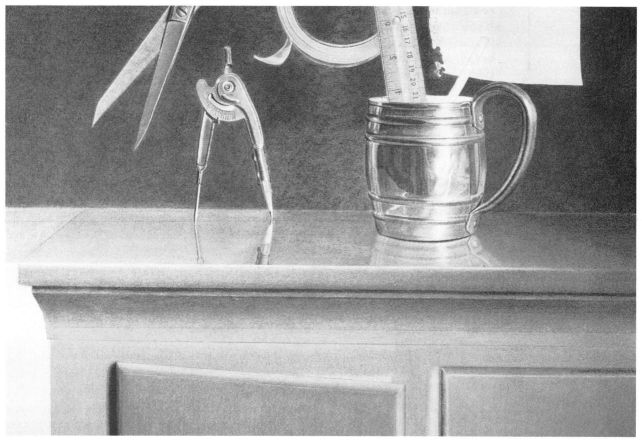

12 Layer and Blend
Blend the front of the cupboard with felt and then layer B charcoal several more times, blending after each layer. Begin rendering the edges of the cupboard doors, but save the inside of the cupboard for last, because it could easily be smeared into the lighter values.

Smooth the Wood
Think about the texture you want to achieve before you begin establishing the values. To simulate a smooth, finished look of wood, I layered with a hard charcoal pencil several times. I could have achieved the same value by applying a softer charcoal once, but the texture would have been much rougher.

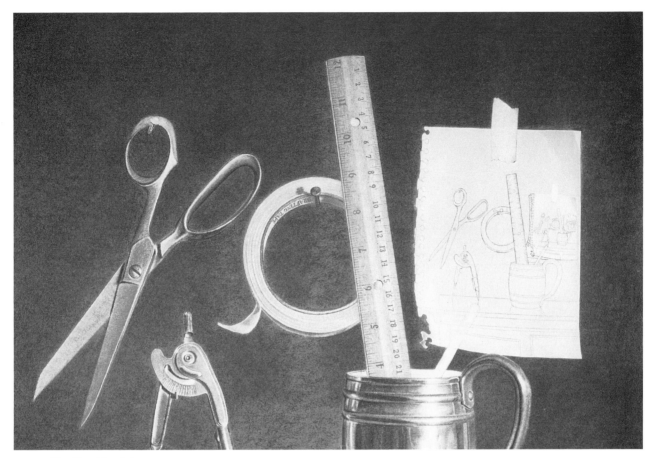

13 The Sketchbook Page

I wanted to bring out the texture of my rag board surface to help imitate the look of paper for the sketchbook page. The best blender for this is another piece of paper, so wrap a piece of notebook paper around your finger and load some 6H graphite onto it. The values will be darkest where you first apply the graphite, so shade the darkest values of the sketchbook page first. The upper right corner of the page bends away from the light source, so begin there. When the value of graphite becomes lighter, move down and put in the medium values. The lower left of the page bends up toward the light, so leave it white.

Use an F graphite pencil to draw the outline of the objects on the sketchbook page. You'll eventually render the second sketchbook page in a more realistic way, so use a kneaded eraser to keep those values white.

14 Beginning the Cast Shadows

This is one of my favorite steps because it really makes the objects pop forward. Start by covering the right side of the drawing to prevent smearing. Then, outline the shapes of the shadows. Use a hard HB charcoal pencil where the shadow and the subject meet to get a clean, sharp edge. In areas where the shadow and the subject do not meet, use a soft 3B charcoal pencil for the outline. Fill in the shadow as dark as possible with 3B charcoal. Then, blend and soften the shadow edges with a small, flat paintbrush.

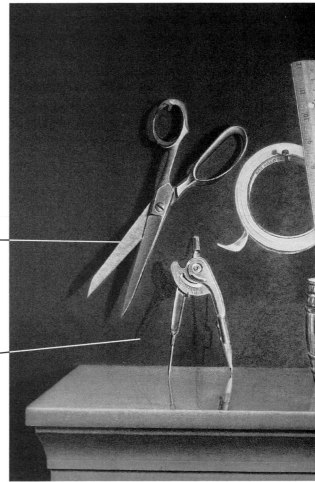

Shadow outline made with HB charcoal here

Soft 3B charcoal here

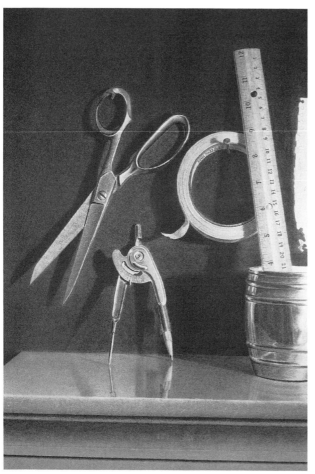

15 Adding Shadows and Correcting Values

Moving from left to right, add more of the cast shadows, and make the final value adjustments in the background, objects and reflections. Render the reflections of the shadows with B charcoal and blend with a tortillon. Soften the reflection of the compass pencil and clean and brighten areas that have become dull with a kneaded eraser.

Where the ruler's shadow falls on the roll of masking tape, add 2B charcoal with a tortillon. Use a lot of charcoal on the tortillon, but dab it lightly, allowing some of the detail and texture of the tape to be seen through the shadow.

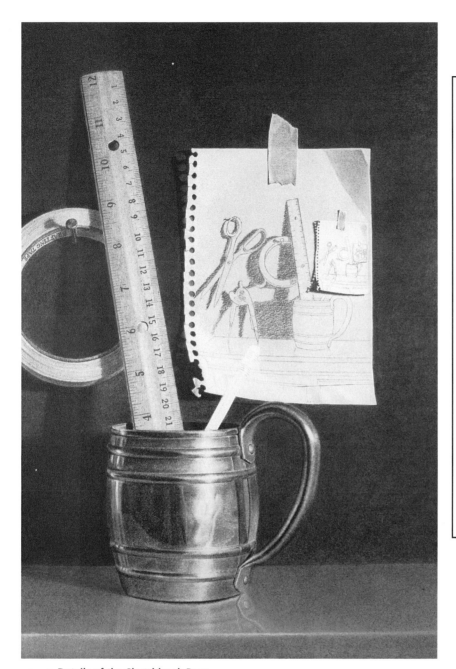

To create the illusion that the second sketchbook page is attached to the first, we must do several things besides lighten the area.

First, the lines in the lower left of the small sketch need to be drawn in perspective. Where the paper curls up, the lines in the sketch of the cupboard must follow the same curve. Second, its shadow must be cast *on* the ruler instead of behind it. Third, the small page would cover the top of the pencil that appears to be drawn on the large sketch. It is on *this* point that I added a twist. Instead of covering up the top of the pencil, I included it and made it appear that it was *drawn* on the small sketch. This is the only major compositional difference between the two sketches. The appearance of this pencil on the small sketchbook page shows the viewer that it is really a sketch *of the larger sketch*, rather than another sketch of the entire drawing.

16 Details of the Sketchbook Page

Start with the tape holding the page onto the wall. Remove the mask off the drafting tape, revealing a perfect silhouette—complete with torn edges. Use a sharp Conté 2H pencil to add texture and details and a tortillon loaded with Conté B carbon to apply the values. Next, add the shadows of the objects drawn on the sketchbook. I wanted the shadows of the scissors, compass, tape and cup to look drawn, so I rendered them with a B graphite pencil with no blending.

The smaller sketchbook page looks real and actually attached to the first. Render it in a realistic way by using a typewriter eraser to lighten the lower left of the page where it curls up and catches more light. Using B charcoal for the cast shadow and Conté B carbon for the tape also adds to the illusion that this little page is attached, rather than drawn.

Finally, fill in the inside of the cup with 3B charcoal. Lightly spray the area with fixative before peeling off the mask of the pencil.

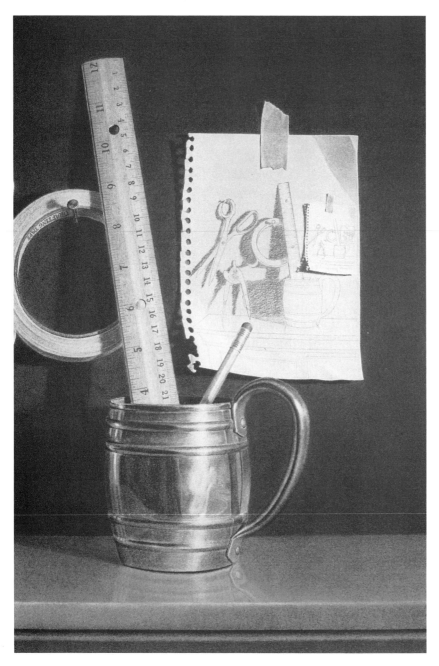

17 Rendering the Pencil

Lightly apply Conté B carbon to the left side of the pencil shaft and blend with a small tortillon. For the lighter values on the right side, apply the carbon directly with the tortillon. Render the metal piece that holds the eraser with values of F and B graphite. Use a kneaded eraser to keep the highlight on the metal as white as possible. By using a sharp HB charcoal pencil applied with stippling, you can produce a good simulation of the eraser's texture.

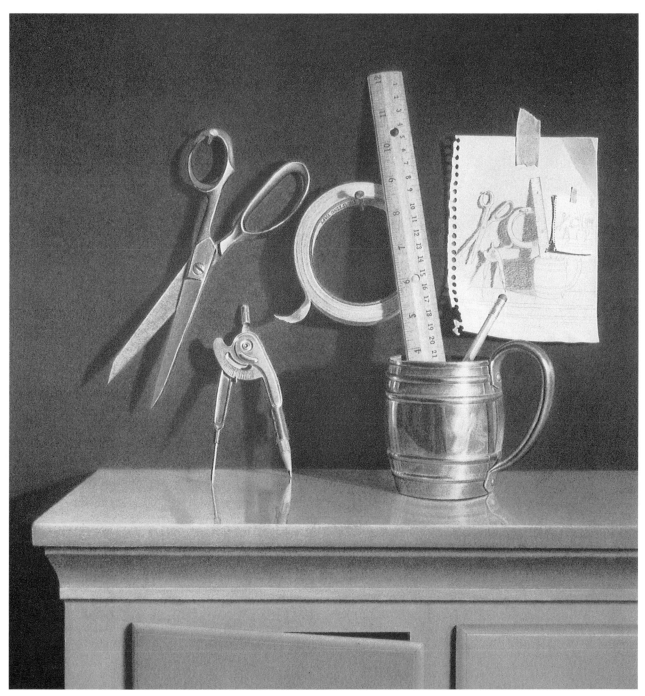

Finished drawing

TORN FROM THE SKETCHBOOK
Charcoal, carbon and graphite on Crescent
100% rag board
20″×20″ (50cm×50cm)

Night Watch

Turning up the Contrasts

While looking through some photos, I ran across this one that a friend had given me about fifteen years ago. The quality of the photo is not the best, but it contains many elements that could make a good drawing. I'm drawn to the contrasts that can be exploited in this very simple composition. The drawing will of course be in black and white. The photo was taken in the daytime, but I can darken the background to make an extreme contrast between the dark of night and the warm white cat. It contains the textural opposites of soft fur next to the rough bricks. I'll also raise the ledge slightly. This altered perspective will increase the feeling that the viewers of the drawing are below the cat. The only other change I made was to increase the tilt of his head to give a more quizzical look.

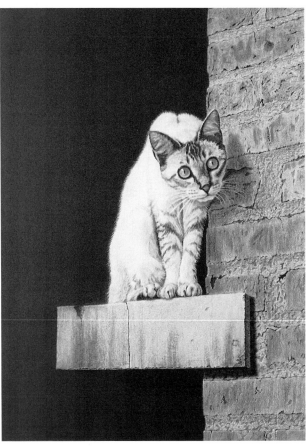

NIGHT WATCH
Charcoal, carbon and graphite on Crescent 100% rag board
16″ × 12″ (40cm × 30cm)
Photo by Richard Stum

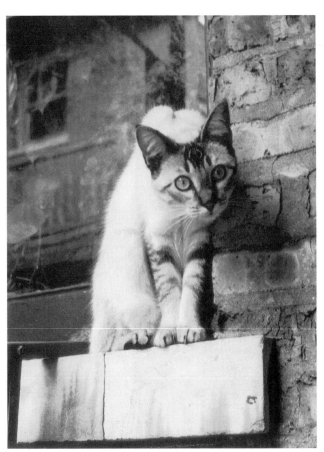

Reference photo

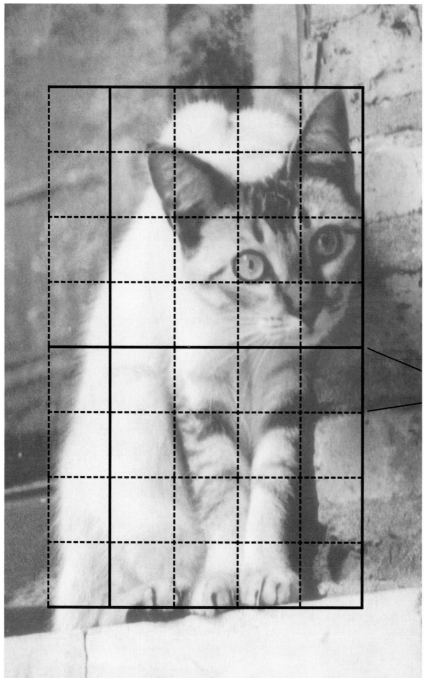

Enlarging a Drawing

To enlarge any drawing, spread the points of a compass to measure between two recognizable sections in the photo. Then, use the compass to look for other elements in the photo that share the same measurement. In this case, I used the length of the cat's head for the initial measurement, and I show how the measurement relates to other important areas in the drawing. To make your drawing larger than a reference photo, simply spread the points of the compass wider before you transfer your first guide marks to your paper. Subdivide this new measurement to plot the same reference points you found on the smaller photo.

Beginning measurement

Divided into quarters

Reference Photo Measurements

You can plot the outside proportions of the cat using a single measurement. Measure straight down along the right side of the cat's face, from the tip of the ear to a line even with his chin. Use the same measurement to plot the distance between his chin and where his feet touch the ledge. Divide the measurement in half and then quarters to obtain the correct proportions in smaller areas. For instance, the width of his left foot is one quarter of this measurement. The head—measuring straight across from where his right ear attaches—is three-quarters of the original measurement. You still need to draw the correct angles and contours between these reference points, but use this single measurement and it's subdivisions to plot guide marks around the perimeter of the cat to get a quick, accurate line drawing. The better you get at recognizing related distances, the less you have to physically measure and plot the reference points in your line drawing.

1 The Line Drawing

Lightly draw the outline of the cat and ledge with an F graphite pencil. Use your compass to plot the proportion guide marks on your paper *as you go*. Once the basic line drawing is complete, sketch the outline of the fur markings and other major features. Apply a dot of liquid frisket to save the white of the paper for the highlights in the eyes. Then, begin darkening the fur on the head with an HB charcoal pencil.

2 Indent for the Whites

Use the indenting technique with tracing paper and a sharp 9H graphite pencil to create the grooves for the white whiskers and the fine lines radiating outward from each pupil. Then, lightly cover the grooves with an F graphite pencil. At this point, use indenting in some areas where white strands of hair extend into the darker areas. Make sure you *pull* the pencil towards you following the direction of the fur to get an even, fluid indentation. Then, start rendering the darker areas of the fur with a sharp 2B charcoal pencil. Do not add too many dark lines at this point.

Draw the Way the Fur Grows
The most important thing to re-
member when drawing an animal
is to make sure the strokes, indent-
ing, blending and erasing follow
the direction that the fur grows.

3 Render the Details of the Fur

Lightly blend the charcoal with a soft tortillon in the direction of the fur. Blending lightly makes it easier to erase for the highlights and the stray white hairs. Use short, tapered strokes with a 3B charcoal pencil for the darkest values of the fur and an HB charcoal pencil for the medium values. Blend the strokes lightly with your tortillon. Apply the charcoal directly with the tortillon to render the very light patches. Finally, use your Clic and kneaded erasers to pull out highlights and more stray strands of white fur.

4 Block in the Bricks

Lightly sketch the outline of the bricks and ledge with an F graphite pencil, and map out the shapes of any major cracks, stains and shadows you want to include in your drawing. Beginning at the top, apply Conté 2B carbon with a chamois to the major shapes. Then, lightly apply 2B graphite with the side of your pencil to make a rough texture for the mortar between the bricks. Holding the pencil with an overhanded or underhanded method works best for this. To render the shadow of the cat, first lay down the Conté carbon to produce the bricks. Over that, apply 2B charcoal blended with felt to make the shadow effect. This keeps the texture and tone of the bricks under the shadow constant.

Make the Drawing Better
Your drawings don't have to look *exactly* like your reference photos. Look for ways to improve the image. To add to the impression that the cat is above the viewer, I included more bricks under the ledge.

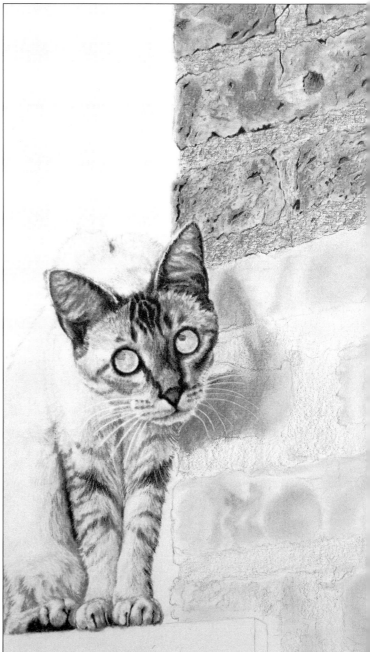

5 Darken the Darks

The bricks need a wider range of values to show more texture. Start at the top and work your way down. I just began this process on the brick above the cat's ear. Apply Conté 3B carbon with a chamois over the entire brick. Then, use a large tortillon with more carbon for the darker areas. Later you will erase in some of these sections to make texture highlights, so apply the carbon with a light touch. Try to stay clear of the mortar with the carbon. Then, add Wolff's B carbon for the darkest cracks and holes in the bricks.

6 Refine the Details With Light

Lay down more 6B graphite with the side of your pencil between the bricks. Then, with a small tortillon loaded with Conté HB carbon, draw some random scribbles over this area to look like crevices and recessed areas in the mortar that don't receive as much light. Use a Wolff's HB carbon pencil to add a shadow inside the upper left of each of these areas. Finally, use your kneaded and Clic erasers to pull out highlights on the upper left corner of every high spot. Do the same for the lower right corner of every crack and hole for both the masonry and the bricks. To get a better idea of the type of marks to make and where to highlight, study the finished bricks on page 121.

7 Increase Clarity

As you work your way down, increase the size and contrast of the details. The added size and clarity will make the higher bricks seem farther away. Keep in mind that as the bricks become closer to eye level, the viewer would see less *underneath* each irregularity in the texture.

At this point, you may want to adjust some of the values on the right side of the cat's face where it receives reflected light from the bricks.

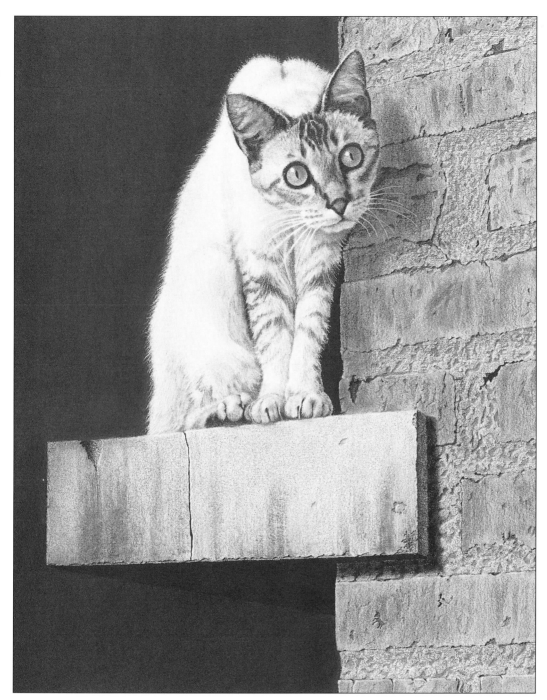

Bricks and Masonry

Here you can see the actual size of the detail in the bricks. My final step was to shade the upper half of the mortar to give it a more concave look.

Don't Go Crazy

You will drive yourself crazy if you try to copy every little bump and stain in the building you see in the photo *or* my drawing. You will have much better luck if you try to identify the surface qualities of the bricks and *imitate* that texture in your drawing. While you invent your own surface details, keep in mind that the light is coming from the upper left and every irregularity in the surface has its own highlight and shadow.

Reflected Light
Because of the reflected light, the right edge of the ledge gradually lightens in value as it approaches the cast shadow on the bricks. This lightening is very subtle, but it helps to visually separate the two. It may take several layers of carbon and charcoal before you are satisfied with the subtle contrast between these areas that are so close in value.

8 The Concrete Ledge

Lightly outline the placement of the major cracks and stains, and then use the side of your pencil to cover the entire ledge with 6B graphite. Use light pressure. The softness of this pencil allows the tooth of your paper to show through and do most of the texturing for you. Then, load a large tortillon with a considerable amount of 3B charcoal. Starting at the bottom of the ledge, use several up-strokes to disperse streaks of the charcoal. Light pressure is needed to let the texture underneath show through. Now you can render the cracks and holes with carbon and erasers by employing the same techniques you used for the bricks.

The right side of the ledge and its cast shadow are close in value. To help separate them, use Wolff's B carbon for the side of the ledge and 3B charcoal for its cast shadow. Wait to render the large portion of the bottom of the ledge until you know the final value of the background.

Turn your drawing sideways when drawing the background to keep the cat clean.

9 Darken the Background

To begin this step, use another piece of paper to cover where your hand may rest on the cat while you draw. Then, outline the fur on the back of the cat with a 2B charcoal pencil. Make sure you draw around some strands of fur standing up. Don't get too dark here since you'll later blend away all of the visible strokes.

Turn your drawing sideways, as it's shown here, so all of the dust and charcoal particles will not fall onto the cat. In the upper left (below the bricks) of your *sideways* drawing, begin applying 3B charcoal using the technique described in chapter two called *Texture With One Value* (page 26). Using medium pressure, continue until you reach the lower right corner of your paper. Try to execute this technique without your drawing hand touching your paper.

10 Black as Night

Use circular blending with felt to smooth out the charcoal strokes as much as possible. A small tortillon works best to blend the areas next to the fur. Keep your paper sideways, and crosshatch over the previous lines with more 3B charcoal. Repeat this technique with increasing pressure, using diagonal strokes in both directions. Blend with the felt after each layer. The objective is to obliterate the tooth of the paper, so after the diagonals you may need to repeat these steps beginning with vertical lines. After the final application of charcoal, use a large flat paintbrush to gently sweep the excess charcoal away from the cat and off your paper. Use long, even strokes to make the background as smooth as possible. Avoid touching this completed area while you render the bottom of the ledge with layers of 3B charcoal. Use the same technique as for the background, but leave out the blending. This should be the darkest value in your drawing.

The eyes are the last part to render, and completing them really enlivens the image. Remove the frisket, revealing the white that becomes the highlight in the iris. Next, render each iris with F and 2B graphite. Use a sharp Wolff's B carbon pencil for the dark pupils. Pay close attention to their placement because they help determine the direction the cat is looking.

Use your kneaded and Clic erasers to pick out some stray hairs standing up on the cat's back. Finally, use the erasers to clean up the highlights and any other areas containing unwanted charcoal.

Don't Be Afraid of the Darks

This is both the easiest and the scariest part of doing this drawing. With charcoal, make the blackest background possible right next to the pretty white cat you have worked so hard on. I understand your apprehension. But if you take some precautions, the cat will stay clean. Remember, to make the cat look like it could leap off that ledge, you need *contrast*.

NIGHT WATCH
Charcoal, carbon and graphite on Crescent 100% rag board
16″×12″ (40cm×30cm)
Photo by Richard Stum

Index